TITLE _____ YES

_____ YOU ___

___ CAN ___

Thanks to my daughter, Esme, for not drawing on
any books; and my husband, Ian, for his editing;
Pat, for his editing; and Debbie and Pat, for their
"support." Many thanks to the self-help speakers,
writers, gurus, and experts for being so optimistic,
and for creating such wonderful and spirited pro-
ducts; and the publishers, record labels, and vari-
ous companies for producing the products. At
Chronicle Books, thanks to Alan Rapp, for his ini-
tial encouragement, and my editor, Steve Mockus,
for his continuous encouragement and enthusiasm.
A special thanks to my friend Richard Reddig,
who provided some great album covers for the
book, and even photographed them for me.

This compilation copyright © 2000 by
Jennifer McKnight-Trontz.

Page 108 constitutes a continuation of the
copyright page.

Every effort has been made to trace the
ownership of all copyrighted material included
in this volume. Any errors that may have
occurred are inadvertent and will be corrected
in subsequent editions, provided notification
is sent to the publisher.

Library of Congress Cataloging-in-Publication
Data available:
ISBN 0-8118-2713-5

Printed in Hong Kong.

cover + book design:
HALEY JOHNSON DESIGN COMPANY

Distributed in Canada by Raincoast Books
8680 Cambie Street
Vancouver, British Columbia V6P 6M9

10 9 8 7 6 5 4 3 2 1

Chronicle Books
85 Second Street
San Francisco, California 94105

www.chroniclebooks.com

YES YOU CAN

TIMELESS ADVICE
from
Self-Help Experts

My waist measure is.............My height is.............

Name...

Address...

City...........................Zone.....State.............

JENNIFER McKNIGHT-TRONTZ

CHRONICLE BOOKS
SAN FRANCISCO

INTRODUCTION

IT USED TO BE FUN, self-improvement, marked by a boundless optimism and faith in the ever-perfectable you. It was easy, and you could do it, with a little help from the experts. All manner of books, records, contraptions, pills, programs, and pamphlets attested to the idea that you could be better—thinner, richer, smarter, stronger, sexier, in charge, and more popular—if only you followed their sage advice. Often it took just minutes. We all want to improve ourselves, don't we? And maybe we've only got a few minutes.

Today we know better. We live with the dreary knowledge that, in the complexity of modern society, we suffer from complexes, dependencies, syndromes, and disorders, and the best we can hope for is to be in an endless process of "recovery." Where's the fun in that? I want to be better right now—at least tell me it's possible. Certainly there's no shortage of ingratiating improvement material out there, with the advent of the website, videotape, and the infomercial, but the messages seem targeted to the darker emotional crevices of our crowded modern minds: I'm not so OK, and neither are you, and the best we can do is manage our deficiencies.

The concept of self-improvement and perfectability is as American as Plymouth Rock. Puritans hawked self-help pamphlets to fretful colonists seeking to lead more godly lives, all of whom were here in the first place looking for a better life. Founding father Benjamin Franklin perfected self-help methods he derived from his everyday life and routines, and wrote at length on how others could benefit from his tested advice. Founding father of another sort Dale Carnegie and his HOW TO WIN FRIENDS AND INFLUENCE PEOPLE inspired fledgling businessmen to not merely succeed in their own communities but to impress themselves in the national character. Carnegie's how-to remains a classic of the genre. According to Jeff MacGregor, writing in *Los Angeles* magazine in 1997:

> HOW TO WIN FRIENDS AND INFLUENCE PEOPLE is still the best of its kind because back in the dear, dark days before "lifestyles" and "empowerment" and "shame spirals" there was only success and how much of it you had. Carnegie teaches you the facial expressions necessary to sell all that which must be sold. No bothersome inner life here, just a hearty handshake and the directive: "Smile!"

Carnegie's tightly focused theology of optimism carried over into the 1950s and 1960s. "Do-it-yourself," "Learn," "In Minutes," and "How To" were stamped on countless records, books, products, and ads.

In 1952 Norman Vincent Peale assured Americans that the secret to success was a simple belief that you could succeed, and Americans were glad to hear it: Peale's THE POWER OF POSITIVE THINKING remained on the bestseller list for years, and is still considered an essential self-help title. Peale's message fit the times. As religious historian Randall Balmer explained, "It was a message of hope, optimism, and American middle-class values," sentiments echoed to national benefit in John F. Kennedy's oft-repeated line: "Ask not what your country can do for you, ask what you can do for your country."

By the 1960s and 1970s there was a book, record, film, or device for nearly every self-help need. You could SOLVE YOUR SEX PROBLEMS WITH SELF HYPNOSIS; relax on the MAGIC COUCH, the couch that does your vibrating for you; learn HOW TO BE A MORE INTERESTING WOMAN; grow taller instantly; know "when to bare your chest." At some point, though, it's impossible to distinguish between success experts meeting the needs of average Americans to better themselves or simply perpetuating them (and where that point is is anyone's guess).

YES YOU CAN focuses on the eras when self-help beamed its best, most hopeful smile, from the 1920s to the 1970s. The material in this book is culled from hundreds of ads, books, pamphlets, and record sleeves; divided into the basic categories of our improvement hopes and fears (Success; Looking Good, Feeling Great; Instant Mind Power; Grooming and Socializing; Love and Marriage), and page spreads focusing on particular themes such as exercise gadgets, diet tips, bending others to your will, and self-hypnosis. I've included cover illustrations where fun or particularly interesting, but refrained from captioning to let the material speak for itself. (A credit list is included at the back of the book for those curious about sources.) Neither a comprehensive survey or history of the self-help movement nor quite self-help's greatest hits, *YES YOU CAN* IS A SYMPATHETIC AND LIGHTHEARTED LOOK AT THE LENGTHS WE'LL GO TO BE "BETTER."

—Jennifer McKnight-Trontz

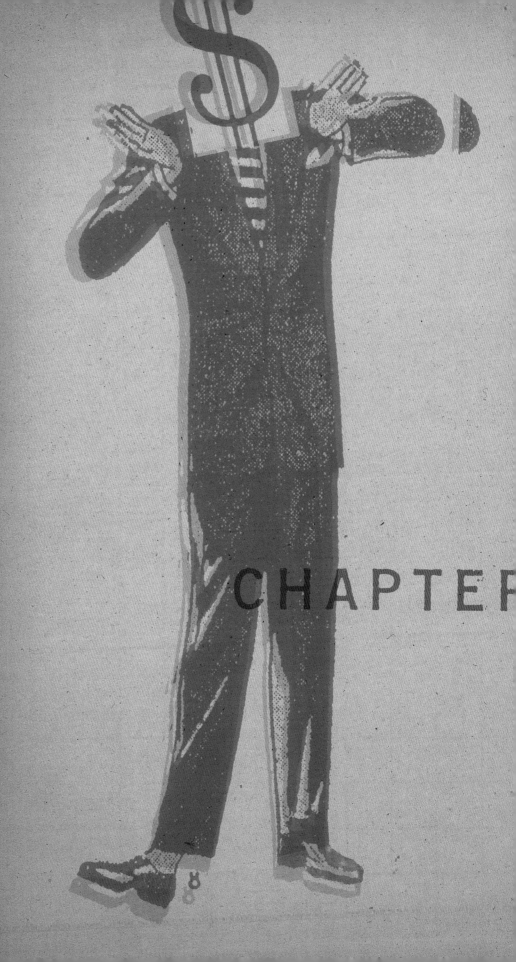

CHAPTER

In the Land of Opportunity success is available to anyone who can afford a book or record. Of course success has many meanings—in a sense all self-help is about success—but we reserve a place of special reverence in our collective psyche for the self-made businessperson, whose success seems derived from steely determination and a sheer will to power. Americans are obsessed with winning, with identifying winners and losers in contests real and imagined, from sporting to financial. We all want to be winners, and look to the experts, those who can and do, to show us the way. Books such as WHEN YOU PRESIDE, MASTERY OF PEOPLE, and THE WORLD CAN BE YOURS assure our place in a better world—one within our reach and ready to do our bidding. The basic success advice formula of practical tips and positive thinking fits the idea that each of us thinks we're special, even exceptional, and that we deserve the promotion, the raise, the new car. We need only learn the six ways of making people like us, the twelve ways of winning people to our way of thinking, the nine ways to change people without giving offense, as outlined by Dale Carnegie, Norman Vincent Peale, Bjorn Secher, and anyone else willing to offer a hand from the other side of the velvet rope. We crave advice on dealing with executive tension, rules for dealing with inferiors, and tips on public speaking, certain of our inevitable APPOINTMENT WITH SUCCESS. When it comes, we'll be ready.

No.

SUCCESS

Fame and Fortune Await You

If you are not interested in making the most of the potentials within you, close this book now! If you *are* interested, put it to work! Your new world will open because *you* will open the door. You will understand yourself better. You will understand people. You will get ways and means of how to cope with them.

EIGHT STEPS TO SUCCESS
REMEMBER:

1: Master your moods—you must not be a Mood Slave!

2: Do it today—you must not procrastinate!

3: Finish what you set out to do—you must not become side-tracked!

4: Prepare a daily schedule—you must not work in hit-or-miss fashion!

5: Continue to work through the Dead-Level stage— you must not become discouraged!

6: Your brain never will tire—you must not cater to the idea of brain fatigue!

7: Find your peak hour of efficiency—you must not try to use your memory-efficiency at the weakest time for your retentive powers!

8: Muscle tension aids your memory-efficiency—you must not work in a relaxed position!

TIARA

MP—1070

POINTMENT
H
CCESS
(Science of Achievement)

RN SECHER

SIDE 1

1.—THE POWER OF YOUR THOUGHTS
HOW TO GET OUT OF LIFE WHAT YOU COULD AND SHOULD

2.—TAKE ONE STEP
HOW TO MAKE POSSIBLE THE THINGS THAT TODAY LOOK IMPOSSIBLE

3.—LIFE IS AN INDIVIDUAL PROPOSITION
HOW TO USE YOUR MENTAL TOOLS: HOW TO OVERCOME LIMITATIONS

SIDE 2

1.—NOT CHANCE BUT CHOICE
HOW YOU ARE THE CAUSE FOR YOUR FAILURE OR SUCCESS

2.—SUCCESS IS A JOURNEY
HOW TO CHANGE FROM FAILURE TO SUCCESS THIS VERY MINUTE

3.—OBSTACLE OR OPPORTUNITY
HOW TO ELIMINATE YOUR PROBLEMS

4.—NOTHING IS IMPOSSIBLE
HOW TO BECOME A WINNER AND STAY THAT WAY.

Make the right choice every time –
Insure your success!
Safeguard your happiness!
Brighten your future!

60¢

HOW
TO MAKE

Rules for talking with

CORRECT
DECISIONS

by GEORGE ANDERSON

- Be dignified.

- Be courteous.

- Be kindly.

- Avoid a domineering attitude.

- Praise him for any good
 work he does.

n inferior might include the following:

- Avoid talking too much.

- Do not be too familiar.

- Never let him overstep
 the bounds.

- Never step down from your own
 superior position.

How I raised myself from **failure** *to* **Success** *in* **Selling**

$2.00

OVER 500,000 COPIES IN PRINT

by **Frank Bettger**

Here it is . . . the most helpful and inspiring book on salesmanship that I have ever read . . . Dale Carnegie

Published Expressly for Mary Kay Cosmetics Directors and Consultants

BUSINESSMEN'S RECORD CLUB

HAMMER HOME the Difference by G. Worthington Hipple

Marketing Consultant, Fedders Corp. Former Eastern Sales Mgr. and Merchandising Mgr. Author and Speaker of "SELL YOURSELF RICH"

BRC 138
LP hi-fidelity

The first man you have to sell is yourself.

Blame Yourself
If This Message Doesn't Bring You A Big Salary Increase

Take any ten average men who are in blind alley jobs at low pay. Analyze each case without prejudice. You'll find that every one of them is solely and entirely to blame for his poor earning power. Every one of them has had a golden opportunity. They either have failed to recognize it, or, recognizing it, lacked the courage to follow it up. But now comes your chance. If this page doesn't bring you a big increase in salary—quick—you have no one to blame but yourself.

By J. E. Greenslade

LET'S be specific. What do you want in life? You want more money than you're getting. You want your own home, a car, membership in a good club, you want to wear good clothes, educate your children and put away enough money to make you independent. If you are like other men, you want to be your own boss in a position that grows every day in interesting fascination. You want to travel, see the world, and meet the wide-awake people who are doing things.

All right. I'll tell you a quick, easy way to accomplish all this. If you don't take it *you* are the only loser. You are the only one who will have to face the accusing finger of *the man you might have been.* If you do take it, you'll thank me the rest of your life for putting this information in your hands. For now it is possible for you to quickly enjoy bigger earnings, and have all the joys in life that your bigger self demands. If this was a guess I couldn't print it. I know it to be a certainty. It is *proved* by the cases of thousands of other men who have done exactly the same thing.

The Secret Is Yours

But, of course, you want to know how it's done. I'll tell you. Although none of the men whose names appear in the panel had ever sold a thing in their lives—though many believed that a salesman must be "born" a salesman—we took them, without experience or training of any kind and in a short period of time made Master Salesmen of them. Then our Employment Department helped them to select the right position and they were off with a boom to the success they had dreamed of.

The National Salesmen's Training Association can do exactly this for you. If this big organization of Master Salesmen and Sales Managers had raised the salaries of only a few men, then you might call it luck. But we've been doing it for fifteen years, day in and day out. Today we're so accustomed to the amazing increases in salary our members receive that we take them as a matter of course.

There is only one thing I ask of you in return for this offer. Don't let the idea of a big salary, the thought of traveling all around the country and meeting worth-while people, make you think that the job is beyond you. Keep an open, unprejudiced mind on this subject—at least until you have seen the remarkable book that I want to send you without charge.

What It Brought These Men

Charles Beery, a farm hand of Winterset, Iowa, was offered this chance. He took it and jumped from $18 a week to a position paying him *$1,000 the very first month.* J. P. Overstreet, Denison, Texas, was on the Capitol Police Force at less than $1,000 a year. He wasn't content with a bare living and he jumped to an *income of $1,800 in six weeks.* F. Wynn, of Portland, Oregon, an ex-service man, wanted the joy of a real success. He earned $544 *in one week.* George W. Kearns, working on a ranch for $60 a month, took the quick road I offer you and *in two weeks he earned $524.* Warren Hartle of Chicago was a railway mail clerk for ten years—in as deep a rut at as low an income as any man could stand. But he wanted success, he longed for the good things of life that he saw other men having. He took my advice and earned *over $7,000 the first year.*

Read This Free Book

This book, "Modern Salesmanship," explains why thousands have quickly succeeded in the selling field—how it is easy to make big money once you are in possession of the Secrets of Selling—how you can quickly get these fundamental secrets, apply them and achieve a quick and permanent success. This is the book I will send you, absolutely free of obligation and expense. Read it through and then decide for yourself.

But remember this one thing: This is your opportunity. If you don't realize a big salary increase from this message, you have no one to blame but yourself. Send me the coupon before you turn this page and I'll send "Modern Salesmanship" immediately.

**National Salesmen's Training Association
Dept. 60-E, Chicago, Illinois**

Don't talk like this:

Talk like this:

✦ Use the funny story or gag to help make a point. Tell your gag and then button up your point. ✦ Condition yourself for the story. Live it as much as you can. Dialect will help. ✦ Don't laugh before the audience is supposed to laugh. ✦ Be prepared for no laugh. Sometimes the listeners will cross you up.

IMPLYING INTEREST
"I'm glad to see you."

"How have you been?"

"I've missed you."

"I've been wanting to meet you."

"You're looking well."

"It's good to see you again."

"I thought you would never come."

"Alone at last!"

HOW TO MAKE PEOPLE LISTEN TO YOU

DOMINICK A. BARBARA, M.D., F.A.P.A.
Certified Practicing Psychoanalyst
Associated with the American Institute for Psychoanalysis

American Lecture Series

A Fawcett Crest Book

t872 75¢

This book could be worth
a million dollars to you

THINK AND GROW RICH

by Napoleon Hill

Co-author of
"Success Through a Positive Mental Attitude"
with W. CLEMENT STONE

Newly revised

SIX WAYS TO TURN DESIRES INTO

1: Fix in your mind the *exact* amount of money you desire. It is not sufficient merely to say "I want plenty of money." Be definite as to the amount.

2: Determine exactly what you intend to give in return for the money you desire. (There is no such thing as "something for nothing.")

3: Establish a definite date when you intend to *possess* the money you desire.

4: Create a definite plan for carrying out your desire, and begin *at once*, whether you are ready or not, to put this plan into action.

5: Write out a clear, concise statement of the amount of money you intend to acquire, name the time limit for its acquisition, state what you intend to give in return for the money, and describe clearly the plan through which you intend to accumulate it.

6: Read your written statement aloud, twice daily, once just before retiring at night, and once after arising in the morning. As you read—see and feel and believe yourself already in possession of the money.

GOLD

How to
manage
your money

by FAYE HENLE

When You
PRESIDE

Outlines and Illustrates How to plan and conduct:

Informal group discussions

Formal business meetings

Service club meetings

Committee meetings

Conferences

Panels and symposiums

Business conferences

Staff meetings

How to

SUTHERLAND

The Author of *HOW I TURN ORDINARY COMPLAINTS INTO THOUSANDS OF DOLLARS* now tells you . . .

HOW TO GET THE UPPER HAND

Simple Techniques You Can Use to Win the Battles of Everyday Life

RALPH CHARELL

An amazing new way to develop confidence and power in dealing with people — a practical blueprint for

MASTERY OF PEOPLE

How to Gain Lasting Power Over People
This book shows you how to:

✓ Impose Your Will
✓ Give Orders That Get Results
✓ Master People In Groups

✓ Strengthen Your Hold on the Opposite Sex
✓ Become A Commanding, Dominant Personality
✓ Read People's Minds

by AUREN URIS

ncrease Your INFLUENCE and CONTROL

With the secret right in the palm of your hand you launch out. You dominate not just one person or a small group of people but everyone you meet! And that's not all. With your new personality, *people will want to meet you.* They'll seek you out, shake your hand, introduce themselves—and actually be flattered that you take notice of them.

YOU are just as good as the BEST. We are all cut from the same pattern and the same material. It has been a wrong viewpoint that has caused you to feel inferior.... The world CAN BE YOURS and will be if you do YOUR PART toward making it so.

What Enthusiasm Does for You Physiologically

1. Aids digestion.
2. Improves metabolism.
3. Relieves tension.
4. Improves muscle function.
5. Stimulates circulation.
6. Steps up endocrine action (hormones).
7. Stabilizes the blood pressure.
8. Stimulates a dynamo of energy.
9. Provides a feeling of euphoria (well-being).
10. Establishes reserve power for periods when you are feeling low.

BELIEVE IN YOURSELF! Have faith in your abilities! With-out a humble but reasonable confidence in your own powers you cannot be successful or happy. But with sound self-confidence you can succeed. A sense of in-feriority and inadequacy interferes with the attainment of your hopes, but self-confidence leads to self-realization and successful achievement.

A BOOK THAT HAS STARTED MILLIONS OF MEN AND WOMEN ON THE ROAD TO SUCCESS AND HAPPINESS

Here are 12 things it will do for YOU:

1. Get you out of a mental rut, give you new thoughts, new visions, new ambitions.

2. Enable you to make friends easily.

3. Increase your popularity.

4. Help you to win people to your way of thinking.

5. Increase your influence, your ability to get things done.

6. Enable you to win new clients, new customers.

7. Increase your earning power.

8. Make you a better salesman, a better executive.

9. Help you to handle complaints, avoid arguments, keep your human contacts smooth and pleasant.

10. Make you a better speaker, a more entertaining conversationalist.

11. Make the principles of psychology easy for you to apply in your daily contacts.

12. Help you to arouse enthusiasm among your associates.

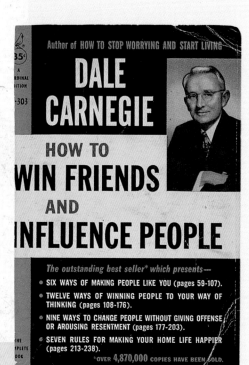

Author of HOW TO STOP WORRYING AND START LIVING

DALE CARNEGIE

HOW TO WIN FRIENDS AND INFLUENCE PEOPLE

The outstanding best seller* which presents—

- SIX WAYS OF MAKING PEOPLE LIKE YOU (pages 59-107).
- TWELVE WAYS OF WINNING PEOPLE TO YOUR WAY OF THINKING (pages 108-176).
- NINE WAYS TO CHANGE PEOPLE WITHOUT GIVING OFFENSE OR AROUSING RESENTMENT (pages 177-203).
- SEVEN RULES FOR MAKING YOUR HOME LIFE HAPPIER (pages 213-238).

*OVER 4,870,000 COPIES HAVE BEEN SOLD.

HOW TO WIN FRIENDS AND INFLUENCE PEOPLE is the world's outstanding guide in the field of human relationships. Read it and improve your personality, secure your happiness, enhance your future and increase your income.

HOW TO BE ADAPTABLE

Rule 1:
Be willing to move to new localities when necessary.

Rule 4:
If he has to work at home, make it easy for everybody.

Rule 5:
Give up your own career if it conflicts with his interests or happiness.

Rule 2:
When he has to work overtime, accept it without resentment.

Rule 6:
Keep up with your husband— don't be the girl he left behind him.

Rule 3:
Be willing to adjust to special conditions imposed by his job.

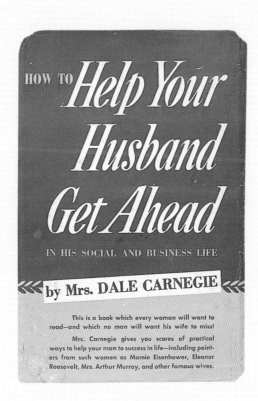

HOW TO *Help Your Husband Get Ahead*

IN HIS SOCIAL AND BUSINESS LIFE

»»» by Mrs. DALE CARNEGIE «««

This is a book which every woman will want to read—and which no man will want his wife to miss!

Mrs. Carnegie gives you scores of practical ways to help your man to success in life—including pointers from such women as Mamie Eisenhower, Eleanor Roosevelt, Mrs. Arthur Murray, and other famous wives.

$⊦➡ Dale and Mrs. Carnegie

The turn of the century saw the demise of the well-fed Victorian ideal, and a radical new "you can't be too rich or too thin" ideology began to permeate American culture. By 1954, *Look* magazine declared that our national standards of beauty had dropped fifty pounds in fifty years. As soon as women shed their corsets they were expected to shed pounds as well, and an industry quickly swelled to aid them. Men, too, were encouraged to slim down and bulk up, be taller, and develop crushing handshakes.

Most of us long for a magic bullet solution for our problems, the one (or ten) golden diet and exercise tip, trick, or device based on scientific and dietary authority we only slightly understand. We believe, or want to believe, in weight-loss voodoo. We want to lose weight by listening to records, by wearing wonder belts, or by lying on Magic Couches. Actual exercise and diets are OK if their results are assured by the experts—strongmen, beauty queens, exercise trainers, fitness celebrities, doctors, models, actors, anyone willing to share their own special secrets. Secrets revealed for a few slim dollars.

LOOKING GOOD, FEELING GREAT

6th session

facial routines

In doing the spade work that precedes the blossoming of beauty . . . there are exercises to be taken that may seem actually funny. These grimaces come under that heading, but don't let that discourage you . . . do them anyway . . . in the privacy of your bedroom, or behind a locked bathroom.

There's a purpose for each of them. Actresses, whose youthful contours you've admired on the stage and screen understand this, and do exercises in the form of new expressions by the hour before their mirrors. These routines were designed to counteract the tension of our modern pace of living that leave their marks upon our faces. Have you ever noticed how, when things go wrong, you clench your teeth and set a little muscle in your jaw? After a while that muscle becomes over-developed, and "sets". Resolve that from now on, the only ways in which you are going to exercise your facial muscles, excepting those involved in laughter, are the ways given here. They should help to relieve tension, make your facial muscles more flexible, and what they should do for your contour . . . well try them and see!

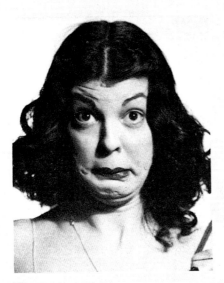

No. 73 — (Above) To develop muscles of the jaw, neck and chest & prevent wrinkles in forehead and around eyes. Draw down corners of mouth, at the same time stretching eyes open as wide as possible. Then clench jaws together.

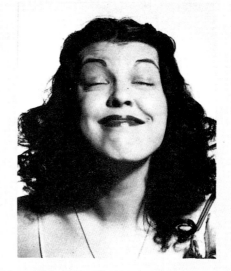

No. 74 — (Above) To develop the muscles in the center of your face, prevent wrinkles around mouth and mold chin. Close eyes and push eyebrows up. With your mouth wide open, attempt to close lips.

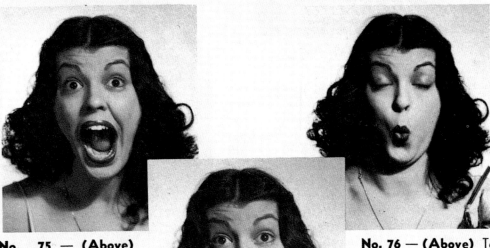

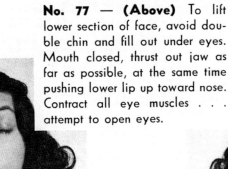

No. 75 — (Above) To relieve the tension of contraction induced in Exercise No. 74, by opening mouth wide and stretching its sides as much as possible, lifting eyebrows and contracting forehead.

No. 76 — (Above) To Strengthen muscles of the mouth and to prevent laugh lines. Purse lips strongly and push forward, lifting the eyebrows and contracting forehead.

No. 77 — (Above) To lift lower section of face, avoid double chin and fill out under eyes. Mouth closed, thrust out jaw as far as possible, at the same time pushing lower lip up toward nose. Contract all eye muscles . . . attempt to open eyes.

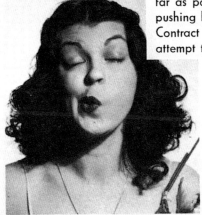

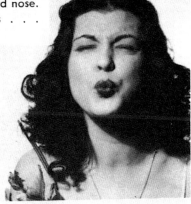

No. 78 — (Above) To round out cheeks and strengthen muscles of jaws. With mouth closed, push jaw to one side, also pushing closed mouth to same side as hard as possible. Reverse. Keep eyes closed, contracting muscles about eyes.

No. 79 — (Above) To perfect contour of chin, stimulate muscles under eyes and increase circulation. Draw features together, contracting every muscle toward center of face. Face takes shape of a circle.

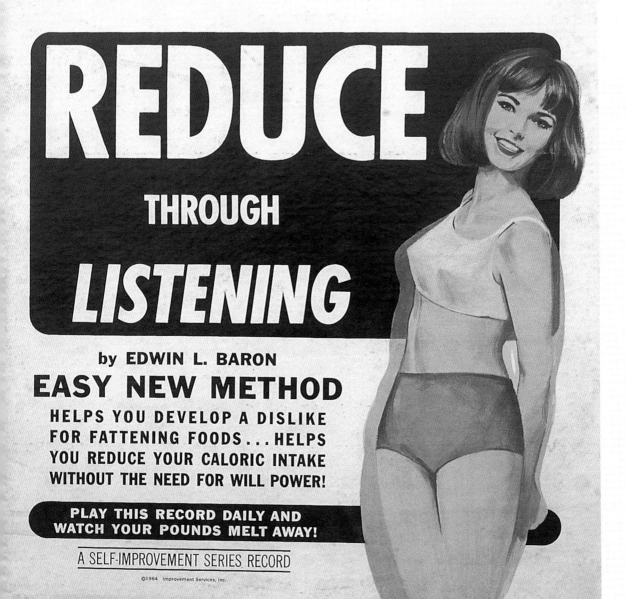

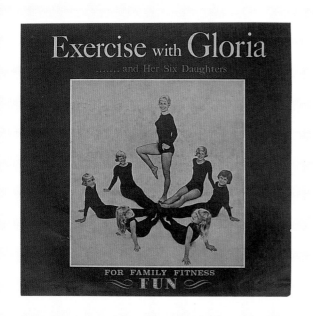

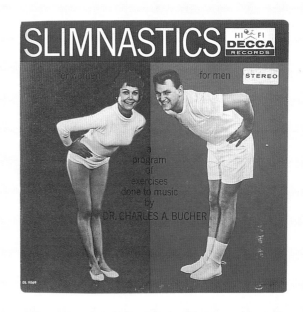

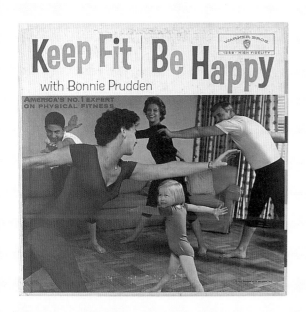

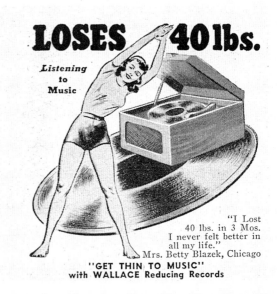

THE BEST TIME TO EXERCISE

IN THE MORNING

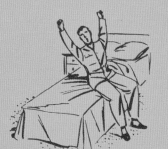

A good stretch in the morning to get the kinks out of your muscles is a swell idea. Get into the habit of doing deep breathing every morning when you get up.

The best time to exercise is before eating, or an hour after you have a meal.

Brisk exercise followed by a stimulating shower is the right way to begin the day.

IMPORTANT NOTE:

It is particularly important for any person who plans to take a course in self-development . . . whatever the method . . . to bear in mind certain fundamental facts in order to understand what results may reasonably be expected.

It is generally recognized that no two persons are exactly alike, scientifically speaking, nor do any two persons react exactly alike. A food that agrees with one may disagree with another. One person can exercise for a given length of time with ease, another may be fatigued by the identical effort.

There are various reasons for this difference in reactions: some are relatively superficial, such as one's mood or surroundings; others are fundamental and deep-seated, such as heredity, basic physical structure, age, state of health, and related factors.

Consequently, it must be borne in mind that the probable results from this course are necessarily restricted by any one or combination of factors such as those outlined above. I wish to make it clear, also, that this course is not designed, in whole or in part, to serve as a substitute where medical therapy is indicated, as for example, in cases of glandular disturbances.

Aside from the foregoing qualifications, any normal person may expect to obtain results in proportion to the diligence and precision with which the principles of this course are applied.

YOU'RE HUNGRY — SO EAT!

Now you are ready for breakfast. You have earned it and how you will enjoy it!

PICK THE TIME TO EXERCISE

Whether you choose to do your exercises in the evening or morning the benefits will be the same. Determine which time of day best suits your convenience, and set that hour as your daily muscle-building period. If it is at all possible for you to undertake the routines in both the morning and again in the evening, by all means do so.

WHEN TO EXERCISE

It is best to exercise before eating. However, if this is not possible, let at least an hour pass after the meal. This will allow sufficient time for digestion before the exercises draw the blood away from the stomach and to the muscular tissues being affected by the exercises.

THESE TWO THINGS ARE IMPORTANT:

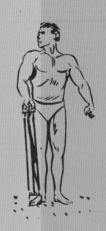

Exercise causes you to breathe more heavily than is customary. Be sure that your room is properly ventilated and well-aired.

Cumbersome clothes will only prove a handicap during these sessions. I would recommend that you do these exercises while wearing only shorts.

10 . . . JOE BONOMO'S JR. CABLE COURSE

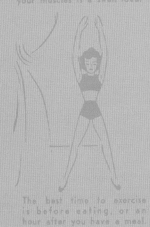

A good stretch in the morning to get the kinks out your muscles is a swell idea.

The best time to exercise is before eating, or an hour after you have a meal.

Brisk exercise followed by a stimulating shower is the right way to begin the day.

Now you are ready for breakfast. You have earned it and how you will enjoy it!

IN THE EVENING

Put aside all the cares of the day when you sit down to dinner at night. Take your time and eat slowly.

RELAX YOUR MIND AND BODY

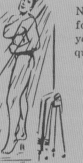

Relax your mind with a good book, and relax your body in your favorite chair, sofa or bed. Be sure you have a good light to read by.

NOW, LET'S EXERCISE!

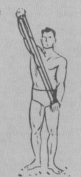

Now is the time for evening exercises. Make them short and snappy. If you did them this morning, pick out a few and do them again. It doesn't hurt.

NEXT A WARM BATH OR SHOWER

Next a warm bath or shower to put you in the mood for a long, soothing sleep. Let the warm water relax your body—so don't try to get this over with quickly.

THAT'S ALL! GOOD NIGHT!

Good night! Sleep well and you will awaken a stronger and more dynamic man. If you have trouble going to sleep, after all your exercising, drink a warm glass of milk and try to relax mentally.

WHAT THE NAME *BLACK BEAUTY* MEANS TO YOU!

By JOE BONOMO

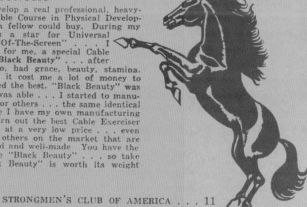

All my life I have wanted to develop a real professional, heavy-duty exerciser to go with my Cable Course in Physical Development . . . the best exerciser that a fellow could buy. During my years in Hollywood, as a star for Universal Pictures and "Hercules-Of-The-Screen" . . . I designed, and had made for me, a special Cable Exerciser. I named it "Black Beauty" . . . after my horse because it, too, had grace, beauty, stamina, power and speed. Sure, it cost me a lot of money to make it . . . but I wanted the best. "Black Beauty" was it! ! Just as soon as I was able . . . I started to manufacture "Black Beauty" for others . . . the same identical exerciser I used. Because I have my own manufacturing plant, I can not only turn out the best Cable Exerciser . . . but I can sell them at a very low price . . . even lower than some of the others on the market that are not half so strong, rugged and well-made. You have the best . . . when you have "Black Beauty" . . . so take good care of it. "Black Beauty" is worth its weight in gold!

STRONGMEN'S CLUB OF AMERICA . . . 11

Put aside all the care of the day when you sit down to dinner at night.

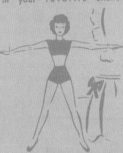

Relax your mind with a good book, and your body in your favorite chair.

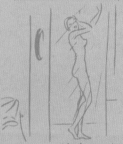

Now is the time for evening exercises. Make them short and snappy.

Next a tepid shower to put you in the mood for a long, soothing sleep.

Good night! Sleep well and you will awaken a more beautiful woman

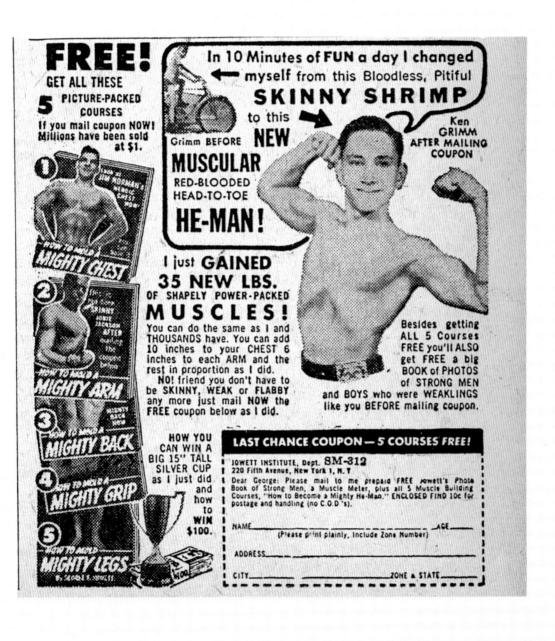
LOOKING GOOD, FEELING GREAT

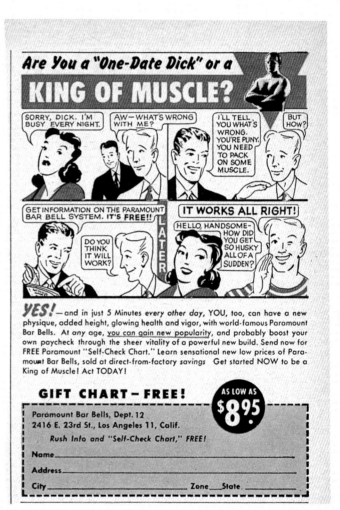

ARE YOU TOO SHORT?
WOULD YOU LIKE TO BECOME
2" TO 4"
TALLER
IN ONLY 6 WEEKS?

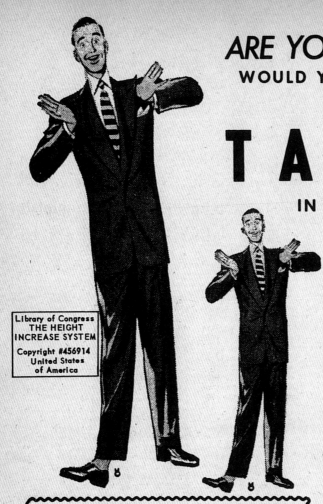

Library of Congress
THE HEIGHT
INCREASE SYSTEM

Copyright #456914
United States
of America

SCIENTIFIC PROVEN METHOD

Yes, you can increase your height in a matter of weeks by using the famous HEIGHT INCREASE METHOD. Science has proved that growth is possible through the proven principle of "Interstitial Accretions." It has helped many small men and women, and it can help YOU! The HEIGHT INCREASE METHOD is based on scientific facts and designed to utilize the FULL "growing power" of your body.

NOBODY RESPECTS THE
SHORT MAN

In business, in daily life, in social life, in love life, a short man is the object of ridicule. Many jobs require a minimum height; women admire men who are taller than they are; it is ridiculous to dance with a woman who is taller than you are! These are the facts of life. But, now you don't have to stay short. You can add inches to your height and become a man-sized man!

NO DRUGS... NO HARMFUL
EFFECTS

Since 1957 THE HEIGHT INCREASE SYSTEM has helped hundreds of men pass their height measurements for the Police and Fireman physical exams without the use of drugs, pills or mechanical appartus, and without harmful effects. This is a revolutionary system that permits your body to extend itself with visible results in a few weeks.

FREE INTRODUCTORY OFFER

Act now! Get the complete facts. Documented and illustrated information is yours (sent in plain wrapper) at absolutely no cost to you. Just tell us your present height, and we'll send you complete data, absolutely FREE!

Our Guarantee

We guarantee 100% the efficacy of the Height Increase System. To those who do not attain complete satisfaction after use of the system in the manner prescribed, the Height Increase Institute will refund their money in full.

THE HEIGHT INCREASE INSTITUTE

USE THIS COUPON NOW!

Mail to: THE HEIGHT INCREASE INSTITUTE, Dept. MR-3
Box 1902 G.P.O. New York 1, N. Y.

Gentlemen:
I accept your FREE offer and understand that I am under no obligation. Send me (in a plain wrapper) the complete information and data on how I can increase my height. I enclose 25¢ to cover the cost of postage and handling.

USE THIS COUPON NOW!

Name...

Address..

City State

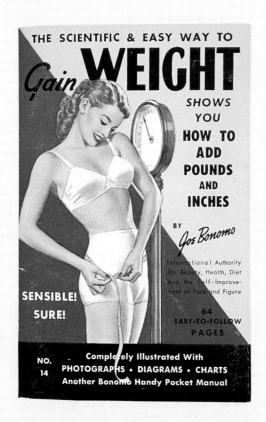

THE SCIENTIFIC & EASY WAY TO

Gain WEIGHT

SHOWS YOU HOW TO ADD POUNDS AND INCHES

BY Joe Bonomo

International Authority On Beauty, Health, Diet And the Self-Improvement of Face and Figure

SENSIBLE! SURE!

64 EASY-TO-FOLLOW PAGES

NO. 14

Completely Illustrated With PHOTOGRAPHS · DIAGRAMS · CHARTS Another Bonomo Handy Pocket Manual

Fad Diets Can Be Deadly

The Safe, Sure Way to Weight Control and Good Nutrition

Written and Illustrated by Frank Netter, M.D.

Foreword by ROBERT M. KARK, M.D.

The truth about fad dieting and an intelligent and effective guide to weight reduction and good nutrition

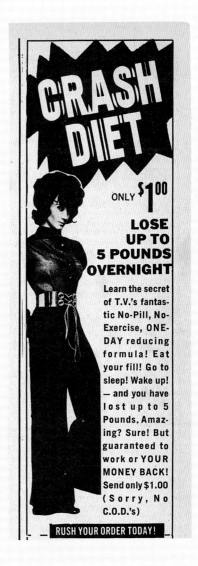

CRASH DIET

ONLY $1.00

LOSE UP TO 5 POUNDS OVERNIGHT

Learn the secret of T.V.'s fantastic No-Pill, No-Exercise, ONE-DAY reducing formula! Eat your fill! Go to sleep! Wake up! — and you have lost up to 5 Pounds. Amazing? Sure! But guaranteed to work or YOUR MONEY BACK! Send only $1.00 (Sorry, No C.O.D.'s)

RUSH YOUR ORDER TODAY!

AT FIRST

MEASURE
EVERYTHING

UNTIL
YOU
LEARN
TO
JUDGE
THE
SIZE
OF A
PORTION

THE BASIC DIET

Breakfast a half grapefruit (or a small orange)
an egg (boiled)
one slice of protein bread (if desired)
coffee, tea or skim milk

$5 **MIND OVER PLATTER**

By **PETER G. LINDNER, M.D.**
Foreword by William S. Kroger, M. D.

CHECK WITH
YOUR DOCTOR

KNOW WHAT
YOU'RE EATING

STUDY YOUR
EATING HABITS

STAY AWAY FROM
FATTENING FOODS

COUNT YOUR
FOOD CALORIES

WHEN YOU'VE HAD
ENOUGH, SAY "NO"

EAT YOUR
EXACT PORTION
... NO MORE!

DON'T THINK
ABOUT EXCERCISE
... DO IT!

Lunch vegetable juice (four ounces)
 lean meat or pot cheese
 large salad
 coffee, tea or skim milk

Dinner bouillon
 lean meat, fowl or seafood
 one green and one yellow vegetable
 melon (in season)
 coffee, tea or skim milk

Mr. Stauffer's "Magic Couch"

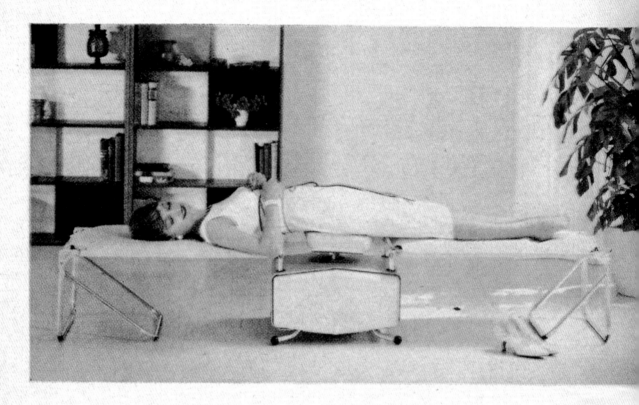

"STAUFFER MOTION" is unique. The oscillating motion of the center section of the "Magic Couch" duplicates the effects of manual exercise. So you get the trimming and firming benefits of manual exercise—but without any of the work. (A simple adjustment provides either forward or side-to-side movement.)

This is the "Magic Couch" that does your exercising for you. The center section of the couch is its only moving part. It oscillates with a pleasant, rhythmic motion. When the body comes into contact with this motion, the result is exercise—the kind of thorough, deep-down exercise you need to help you reduce.

The "Magic Couch" is a scientific development that comes from many years of research and improvement. It is a Stauffer exclusive. Some "look-alike" couches have imitated its appearance, but most of them are mere vibrators which cannot provide real exercise.

Takes the work out of exercise

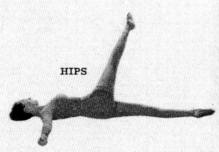
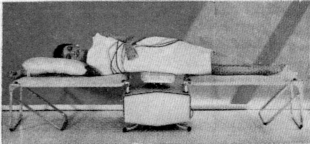

20 times vigorously this way *or* a few relaxing minutes like this

20 times forcefully *or* firm up with no effort at all

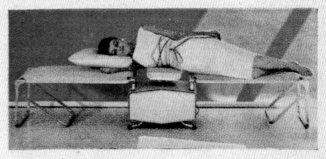

20 times, twisting sharply *or* a little exercising the lazy way

50 times, very rapidly *or* trim down without any work

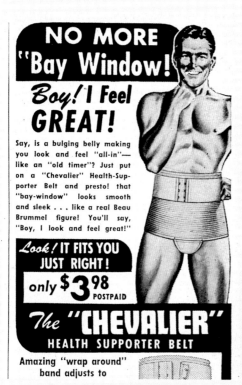
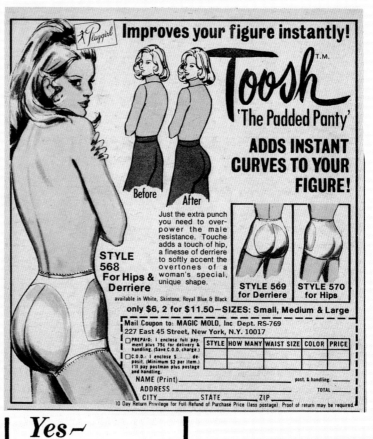

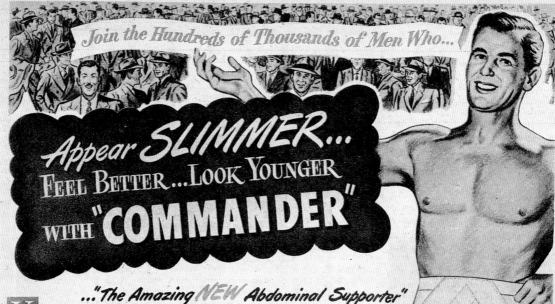
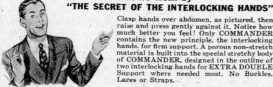
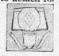

The Wonderful Thing

IN LIFE IS
WOMAN'S SECRET CHARM

What Is It? How Can It Be Acquired?

Are You Lonely?

Many a woman today, who craves companionship and love, suffers in silence without knowing why she is neglected. The *secret* of woman's charm is that natural physical perfection which lends enchantment wherever she goes—the thing that makes her WOMAN in the first place—irresistibly draws man to her. That charm is her "physical beauty."

Bust Pads Will Not Do

No man loves a dummy. There is no appeal in false, physical make-up. Man cannot be deceived. You must be a REAL woman, and because you are, you will want to be as perfectly developed as nature meant you to be.

You Have a Friend

Science comes to your rescue, in the perfection of a wonderful invention which will expand and enlarge the bust of any woman in a surprisingly short time, no matter what the cause of under-development. No creams, no medicines, no electrical contrivances, no hand massage, no fake free treatments to deceive you—but a simple, effective, harmless home developer which you use a few minutes night and morning. That is all there is to do. Nature, thru the physical excitation and stimulation of this wonderful invention, builds up flabby, lifeless tissues into the rounded contour of perfect beauty which every woman secretly craves.

You Can Now Be Happy

and sought after and admired and loved, if you will let us tell you about this remarkable developer, which is the only real method known for permanently enlarging a woman's bust to its natural size and beauty.

Its Results Are Wonderful

Dr. C. S. Carr, former physician of national reputation, says of this physical culture invention:

"Indeed, it will bring about a development of the busts quite astonishing."

Actress "The Follies Company" writes.

"This invention has done wonders for me, having developed an attractive bust of FOUR INCHES in the short time of THREE WEEKS—was never larger than a child's. I cannot express how delighted I am in this changed appearance. I take pleasure in recommending it to my friends of the profession."

Let Us Tell You FREE

without the cost of one penny, just how you may acquire this irresistible charm of womanhood that comes instinctively with a wonderfully developed figure. Send your name and address today and prepare for the happiest moments of your life.

Mail the Coupon Today

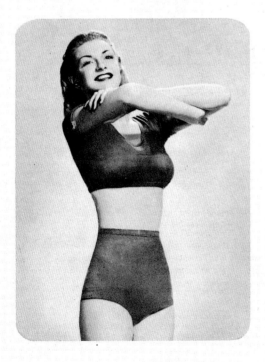

the supporter

When your breast sags it is often because the supporting muscles lack tone. The purpose of this exercise is to strengthen the muscles supporting the breast.

POSITION

Stand erect, hands grasping arms just above elbow at shoulder level.

ACTION

Press hands against opposing arms until a contraction is felt in the pectoral muscles of the chest, then relax.

This movement should be accomplished, and repeated, as a series of short "jerks" or "pushes", contracting and relaxing the pectoral muscles until they become pleasantly tired.

LOOKING GOOD, FEELING GREAT

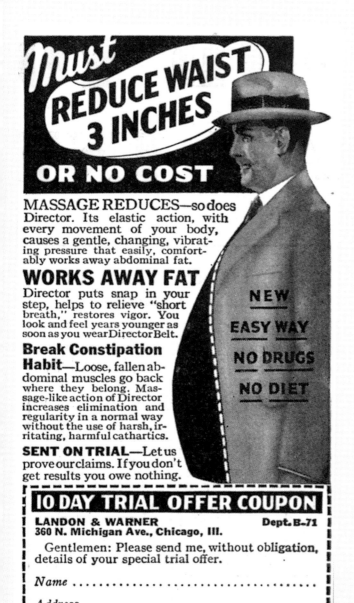
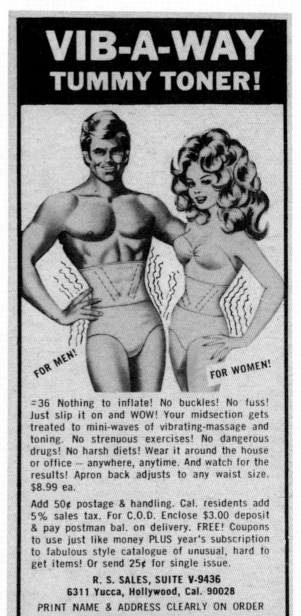

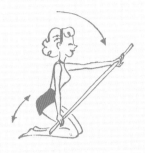
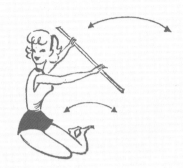
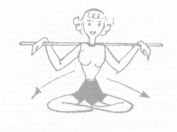

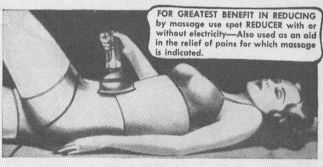
LOOKING GOOD, FEELING GREAT

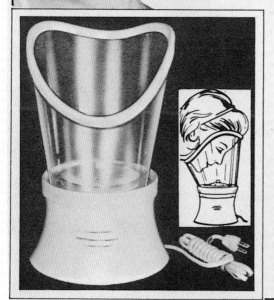

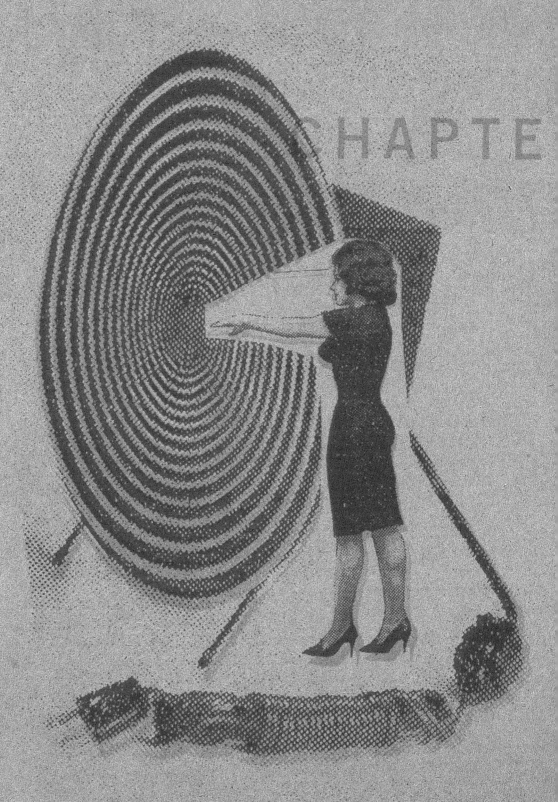

CHAPTE

No. 3

Think faster. Remember more. Double your power to learn—you can do it! Kiss that dumb, forgetful you goodbye.

Nothing impresses like the self-taught, self-made man or woman. As television increasingly programmed the leisure time of the average American, many looked to speed-reading, memory-enhancing courses, and various other mental achievement products and programs to smarten up fast. Just as important as a toned physique, an agile and well-tuned mind holds the promise of deep, meaningful success. And we hope, as promised in Harry Lorayne's INSTANT MIND POWER, that our efforts will make us "a mental magnet that automatically draws friends, power, love, and money far beyond your fondest dreams." We want to wield dangerous mental powers with our X-Ray Minds.

Many of these mental improvement plans operate on the subconscious mind, leaving our conscious minds free to check out entirely. Records offer relaxation and courage. Self-hypnosis promises a way of reprogramming yourself for success in its many forms: lose weight, gain self-confidence, have better sex, improve your golf game. And, if nothing else, there's always THE POWER OF POSITIVE THINKING.

INSTANT MIND POWER

852. noises. So loud, you have to hold your ears. See the picture. Van noise = _____.

853. This is Mr. Hamper. You can use his very wide mouth as the outstanding feature. See yourself cramming all your dirty clothes into his

(see next frame)

853. mouth because it's a hamper. Look at Mr. Hamper and actually ____ this picture in your mind.

854. This is Miss Smith. A common name, but just as easy to forget as an uncommon one if no association is made. Miss Smith's lips are very

(see next frame)

854. full. They appear to be swollen. See a blacksmith swinging his hammer at those lips, causing them to swell. Be sure to ____ the picture.

855. Here's Mr. Kannen. You might select his outstanding ear, or the lines in the corner of his eye, or the thin long mouth as the outstanding feature. Whichever you select,

(see next frame)

The First "Trick" Is Exaggeration

Don't be content to imagine an ordinary ear with a proportionately sized pencil tucked behind it. Make your image very large. Magnify the objects in your mental picture until they are far bigger than natural-size. Make them *unusual!* This uniqueness will make them easy to recall. You have certainly never seen an ear larger than the head to which it is attached. If you had, you would never forget the sight; that is why you will remember the image of a gigantic ear supporting a pencil much longer than any you have ever actually seen.

INSTANT MIND POWER

855. you can picture a <u>cannon</u> either shooting from the feature, or shooting it off. Be sure to actually see the picture. Cannon = _____.

856. This is Mr. D'Amico. You can't miss the full head of wavy hair. See this hair as a gigantic <u>dam</u>. The water is overflowing as you scream 'eek' and 'oh.'

(see next frame)

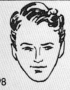

856. Or; you're running toward the dam, shouting 'me go.' See the picture. Dam eek oh, dam me go = _____.

98

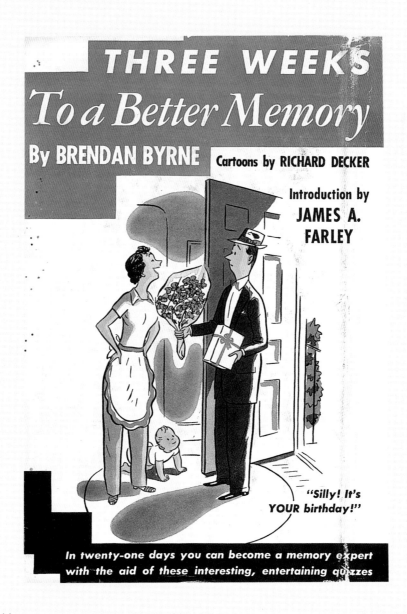

THREE WEEKS
To a Better Memory
By BRENDAN BYRNE

Cartoons by RICHARD DECKER

Introduction by
JAMES A. FARLEY

"Silly! It's YOUR birthday!"

In twenty-one days you can become a memory expert with the aid of these interesting, entertaining quizzes

The following are a few posthypnotic suggestions that the bachelor can give himself during self-hypnosis, which may lead him toward the road to marriage:

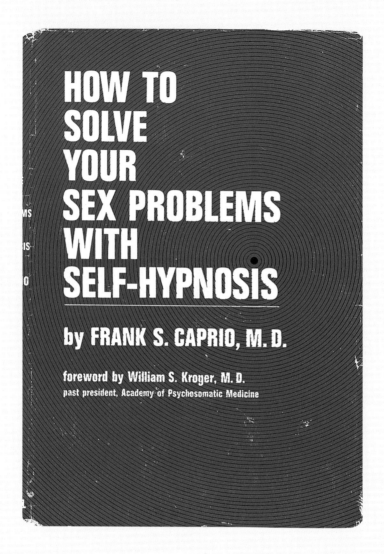

* I am going to take a positive attitude toward women and not entertain the kind of thinking that would impede my desire for women. I must not generalize by saying that "all women are alike."

* I am going to convince myself that there are many advantages to being married.

* I am not going to make compulsive masturbation a substitute for a mature relationship with the opposite sex.

* I am going to read enough books pertaining to sexual technique and marriage so that I can feel confident in my relationships with the opposite sex.

INSTANT MIND POWER

NOW YOU CAN earn more money - enjoy better health - over-come negative habits - develop a magnetic personality - eliminate tensions - increase concentration - actually live longer!

With the complete easy, 3-step method of the famous Sampson-Hayes Technique on

SELF-HYPNOSIS

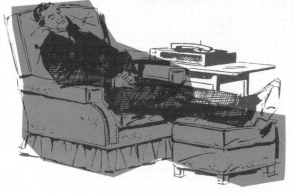

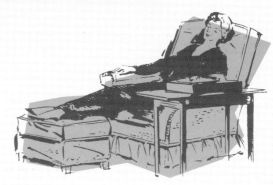

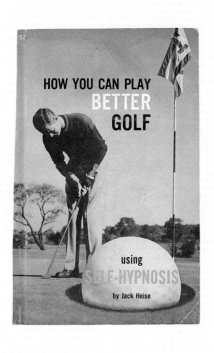

HOW YOU CAN PLAY BETTER GOLF

using SELF-HYPNOSIS

by Jack Heise

FOLLOW-THROUGH

Here is a picture showing excellent follow-through. It is evidence of how well the stroke has been "grooved." Note the player's relaxed muscles at the finish of the swing. This relaxed position is only possible when the stroke has been played with the muscles controlled by the subconscious mind.

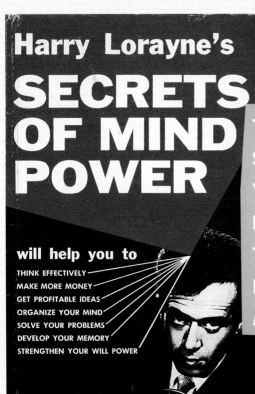

Harry Lorayne's SECRETS OF MIND POWER

will help you to

THINK EFFECTIVELY
MAKE MORE MONEY
GET PROFITABLE IDEAS
ORGANIZE YOUR MIND
SOLVE YOUR PROBLEMS
DEVELOP YOUR MEMORY
STRENGTHEN YOUR WILL POWER

TREMENDOUS PERSONAL POWERS LIE SCATTERED — USELESS — WITHIN YOUR MIND RIGHT NOW! HERE AT LAST ARE THE MENTAL MAGNETIZERS THAT FOCUS AND UNLEASH THOSE POWERS — WITH ALL THE FORCE OF AN EXPLODING VOLCANO!

instant

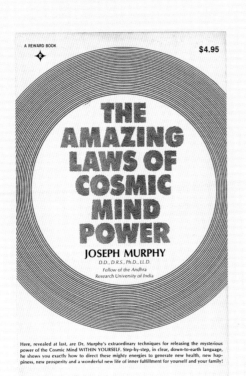

A REWARD BOOK $4.95

THE AMAZING LAWS OF COSMIC MIND POWER

JOSEPH MURPHY
D.D., D.R.S., Ph.D., LL.D.
Fellow of the Andhra
Research University of India

Here, revealed at last, are Dr. Murphy's extraordinary techniques for releasing the mysterious power of the Cosmic Mind WITHIN YOURSELF. Step-by-step, in clear, down-to-earth language, he shows you exactly how to direct these mighty energies to generate new health, new happiness, new prosperity and a wonderful new life of inner fulfillment for yourself and your family!

Law 1: The Astounding Law of Contact with the Cosmic Mind

Law 2: The Secret Law of Faith

Law 3: The Miraculous Law of Healing

Law 4: The Dynamic Law of Protection

Law 5: The Mysterious Law of Inner Guidance

Law 6: The Mighty Law of Courage

Law 7: The Wonderful Law of Security

Law 8: The Magical Law of Mental Nutrition

Law 9: The Great Law of Love

Law 10: The Positive Law of Emotional Control

Law 11: The Thrilling Law of Marital Harmony

Law 12: The Glorious Law of Peace of Mind

Law 13: The Replenishing Law of Automatic Prosperity

Law 14: The Penultimate Law of Creation

Law 15: The Ultimate Law of Infinite Life

mind power

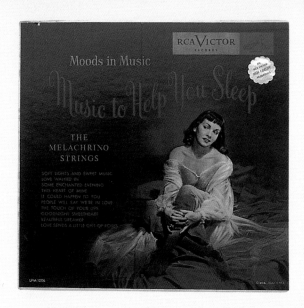

Sleep and Learn

MENTAL THERAPY AND MIND-TRAINING WHILE YOU SLEEP

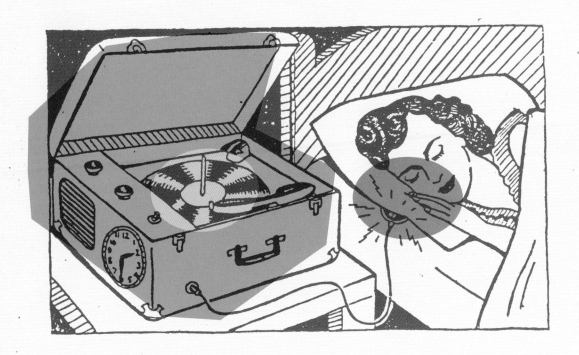

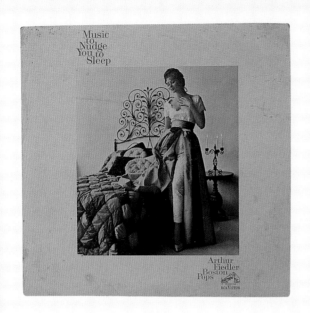

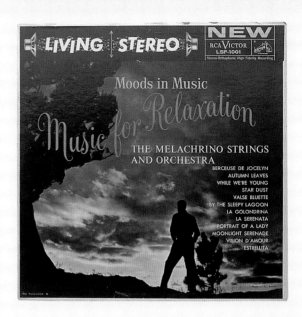

Record the message on your **Audio Educator Cartridge** in a quiet, firm, persuasive voice; allow the automatic action of the cartridge to repeat the message for your sleep-study periods.

Example....I understand that I am equipped to control my actions....I can stop (here clearly name the problem)....I have complete confidence in my ability to stop (problem)....I have trained my mind to accept my suggestions, and I will quickly accept this message because I fully realize I shall be happier for it, and I shall be a better person for being able to control myself by stopping (problem).

DR. J. W. THOMAS

YOUR PERSONAL GROWTH

NOW—Discover Yourself—
so that you can grow and help others to do the same

A person who has dominant strength in courage of independence has strong feelings of *independence* and *self-sufficiency*. He resists being dependent upon any power outside his own. He feels a thrill as he reads "Invictus."[*]

Out of the night that covers me,
　　Black as the Pit from pole to pole,
I thank whatever gods may be
　　For my unconquerable soul.

In the fell clutch of circumstance
　　I have not winced nor cried aloud.
Under the bludgeonings of chance
　　My head is bloody, but unbowed.

Beyond this place of wrath and tears
　　Looms but the horror of the shade,
And yet the menace of the years
　　Finds, and shall find me, unafraid.

It matters not how straight the gate,
　　How charged with punishments the scroll,
I am the master of my fate;
　　I am the captain of my soul.

One Hundred and One Famous Poems, R. J. Cook, ed. Chicago. Reilly & Lee Books, 1919.

Just 15 Minutes *a* Day

Learn FARMING IN YOUR OWN LIVING ROOM

Send for FREE BOOK

Gain the Right to Security and Peace of Mind

Farmers enjoy complete independence, security, a good steady income and a healthy place to raise their families. Farmers do not have to worry about work shortages, layoffs, etc. They are always certain of a place to eat and sleep.

NEW HOME LABORATORY SYSTEM

Teaches you practical Farming "Know How" based on latest scientific discoveries. You learn how to buy or rent the right farm, what crops will grow best, how to secure maximum yields and how to market your produce for peak income.

RAISE CHICKENS— GROW FRUIT TREES

Latest poultry raising facts for getting the most egg yield and the largest return from chickens, turkeys, ducks, etc. Start with a few chickens now to pay for your training and provide extra pocket money. Later expand as you wish. Fruit production pays well when properly handled. Comprehensive course includes sections on raising vegetables, livestock, special crops, etc.

TEST KITS SENT TO YOU
Kits on soil testing, plant propagation, weed control, planning charts, etc., sent to you along with complete data on what to grow or raise for most profits wherever you may settle and how to learn farming in your own home by our DOING and SEEING PLAN.

FREE ILLUSTRATED BOOK
Is yours for the writing. Every farm minded (large or small) person should have it. We will also send you a special form so you can pay for your training from profits made while learning.

PROFITABLE FARMING
5944 N. Newark Ave.
Dept. 301, Chicago 31, Ill.

CHAPTER

Bad hair? How are your manners? Do you know "How Slacks Should Fit to Please Women"? You'd be more popular if you learned Italian, the guitar, ventriloquism, or the hula. (Nothing impresses like raw talent.) You're charming, sure, but are you charming enough? Do pretty clothes really bring happiness? Maybe you should learn HOW TO BE A PARTY GIRL. Nobody smokes anymore, do they?

With so many plates to keep spinning in the theater of social success, we depend on expert advice from the well-groomed, well-heeled, the bright, beautiful, fabulous, and famous to keep any one of them from wobbling too horribly. With the right guidance and a little determination we'll glide into the ballroom, impeccably dressed, hair just so, graceful and gracious, ready to dance the night away. Meanwhile we study at home, polishing our French, improving our personalities in fifteen minutes a day, and learning all the right steps.

No. _____

GROOMING AND SOCIALIZING

The Problems in My Life TODAY:

SIMMONS INSTITUTE PROBLEM-ANALYSIS FORM

Step 1: Just what is my problem? It is:

Step 2: What is its relative importance?

I will put it on my priority list as number _____.

Step 3: What facts do I know about this problem? I know:

What are the unknown factors here? These are:

Step 4: What answers do I need from outside sources? I want to know:

Where will I get these answers? I will ask:

When Step 4 is completed and you have the information needed, then:

Step 5: What is my decision? I will do this:

Date: _____

☆ Do one special thing every month for your appearance; **it may be concentrating on your posture, changing your hair style or trying a new make-up, but try something that will give you a psychological boost and something others will notice.**

☆ Keep a conversation rolling, don't monopolize it. **Have a point of view, but listen to others with an open mind and with your full attention. Ask intelligent questions and** *listen* **to the answers.**

☆ Sharpen your sense of humor **by reading humorous novels, plays, and essays—having such books within handy reach is a cheery home remedy for pulling you out of the doldrums, too.**

☆ Concentrate on at least one special thing each week **to make your home a more enjoyable place to be. It may be placing fresh flowers in all the rooms or buying new throw pillows for the couch or planning a formal dinner with candlelight and all the family heirlooms as a surprise for the family.**

How to Improve Your Personality and Make It Work for You as a Professional Man or Woman · · Parent · · Teacher · · Sweetheart · Entertainer · · Executive · · Salesman · · Office Worker · · Supervisor

By EARL G. LOCKHART, A. M., PH. D.

MENTAL HEALTH RULES

Have several interests. Keep in good health. Try to make other people happy by being friendly. Don't carry a grudge. Don't hate and don't try to get revenge. Don't think too much of yourself or about yourself. Don't run away from reality when staying with it is difficult. Dream if you like, but make your dreams come true. Have a mind of your own and use it. Believe in yourself and in your fellow-man. Follow these rules consistently and you will be *well liked, well adjusted, and influential.*

NEVER SAY:	SAY INSTEAD:
Wealthy	Well-to-do, or rich
Brainy	Brilliant or clever
Pardon *me!*	I beg your pardon. Or, Excuse me! Or, I'm sorry!
Lovely food	Good food
Elegant home	Beautiful house — or place
A stylish dresser	She dresses well, or she wears lovely clothes
Charmed! or Pleased to meet you!	How do you do! Or, I'm very glad to meet you!
Butter spreader	Butter knife
Formals	Formal clothes or a formal dinner
Fellow or chap	Man (or, boy, if under twenty-one)
Boy (when over twenty-one years of age)	Man
Young lady	Girl is proper according to good usage for any unmarried young woman not in business, and not older than early twenties
"Keeping company with" or "walking out with"	(There is no proper equivalent for the phrase because according to etiquette no such situation exists. No man is given the exclusive right to be devoted to any girl unless he is engaged to her)
Gentleman friend	Man friend or "a man who is a friend of mine"
Lady friend	Woman friend or my best girl
Close friend	A best friend or intimate friend
Social affair	A party
In the home	In someone's house or at home
Drapes	Curtains, or, if necessary, draperies. ("Drapes" is seen in the advertising pages every day, but it is still a flagrant example of bad taste)
Phone, photo, auto, mints	Telephone, photograph, automobile (or motor), peppermints

GROOMING AND SOCIALIZING

When telephoning . . .

SAY "THANK YOU" AND "YOU'RE WELCOME"

★ The use of such phrases is one way to smile over the telephone.

HOW TO BECOME CIVILIZED

1. Curb bad temper.
2. Learn how to forgive and forget.
3. Avoid jealousy and envy by considering those less fortunate.
4. Love somebody, or something, earnestly.
5. Never take revenge. It leads to remorse.
6. Practice kindness, consideration and courtesy.
7. Adopt a charity.
8. Foster a religious creed.
9. Think twice before you act.
10. Analyze your emotional reactions and ask yourself why.
11. Weigh and consider all problems impersonally.
12. Consider how it feels to be in the other fellow's place.

PRIX FIXE (prē´fiks), a fixed price: minimum charge.

CANAPE (ka-na-pā´), bread fried in butter and covered with anchovies, cheese, and the like.

CHIC (shēk´), elegance in dress; cleverness; smartness; snap.

ENSEMBLE (än-säṅbl´´), general appearance or effect.

In fashion, the unity of a costume as a harmonious whole.

VALET (văl´et; văl´ā), a valet: a manservant.

HOW TO BECOME A
More Popular
HOSTESS

- Secrets For Successful Parties
- Menus and Party Decorations
- Entertainment For All Types Of Guests
- What To Do About Unexpected Visitors

BY *Joe Bonomo*

64 PAGES

PARTIES FOR ALL OCCASIONS
. . . and many holidays covering all types of entertaining . . . from the mid-morning brunch to the midnight snack buffet.

Completely Illustrated With
PHOTOGRAPHS • DIAGRAMS • CHARTS

NO. 11

Another Bonomo Handy Pocket Manual

Conversational Taboos

Always, personal questions are bad taste. A personal question might deal with some financial equation—how much someone paid for her shoes or what the remodeling of her kitchen cost. It could ask a shoe size, weight, age, whether or not someone wore dentures or dyed her hair. It also could pry into personal relationships. Discussions of illnesses and descriptions of operations are most unfortunate. They have to be stopped somehow.

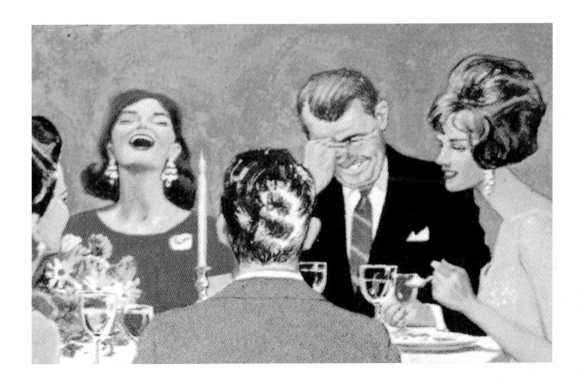

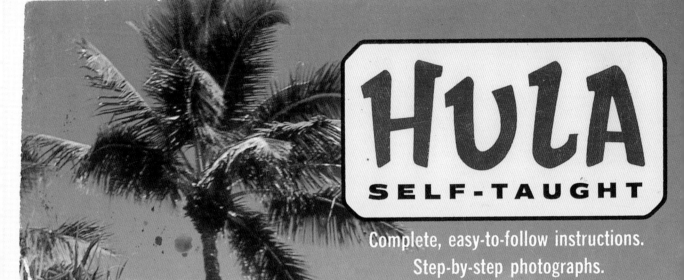

HULA
SELF-TAUGHT

Complete, easy-to-follow instructions.
Step-by-step photographs.

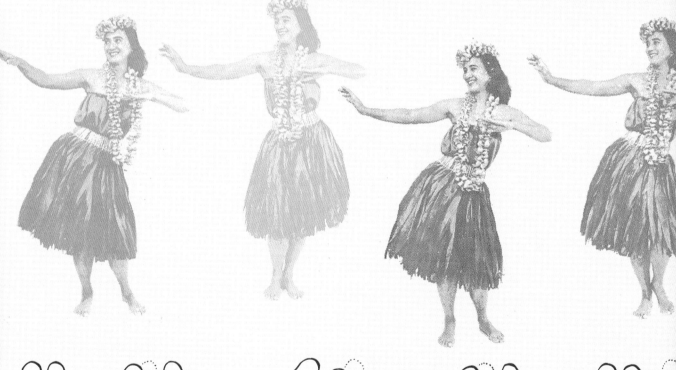

Feet together; one. Two. Three. Rest.

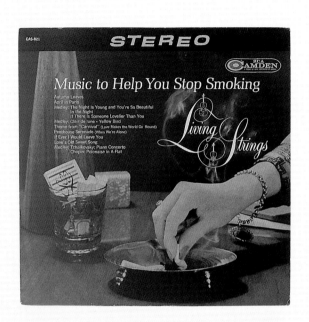

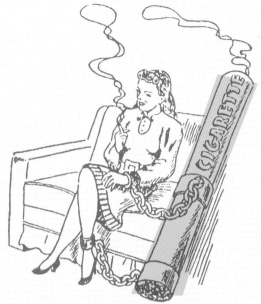

Chained, crushed in spirit and broken in body.

WHAT I HATE ABOUT SMOKING

★ Mouth always tastes terrible
★ Keeps me from sleeping
★ I'm a slave to the habit
★ Cuts my wind and endurance
★ Catch cold very easily
★ Can't stop coughing, throat raw
★ Heart, chest and back pains
★ Don't enjoy taste of cigarettes
★ Burns holes in my favorite suits
★ ALMOST KILLED MY WIFE!
 COULD KILL ME!

GROOMING AND SOCIALIZING

ST🔴P

SMOKING...STOP OVER-EATING

WITH REVEEN

How to get ALONG WITH PEOPLE

by MICHAEL DRURY

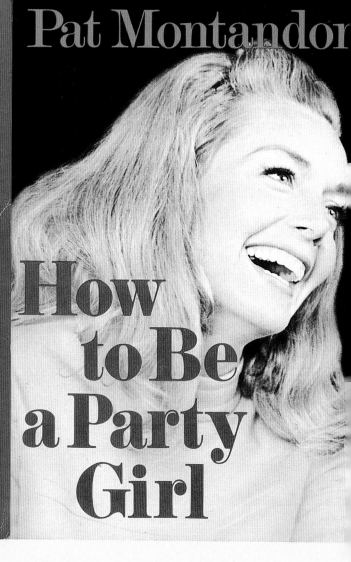

Pat Montandon

How to Be a Party Girl

How To Develop A
More Successful
PERSONALITY
For A Winning & Magnetic "You"!

THE 7
MAGIC KEYS
TO SUCCESS
AND
POPULARITY

BY
Joe Bonomo

64
PAGES

HOW TO TELL IF YOU'RE CHARMING

+ Do you wake up cheerfully?
 1. Never
 2. Occasionally
 3. Often ()

+ Are you pleasant at breakfast?
 1. Never
 2. Occasionally
 3. Often ()

+ Are you well groomed when you check yourself in the mirror before you go out?
 1. Never
 2. Occasionally
 3. Often ()

+ Do you accept housework as a necessary chore which will make you feel better when it's done?
 1. Never
 2. Occasionally
 3. Often ()

+ Do you plan a pleasant surprise for your family or friends?
 1. Never
 2. Occasionally
 3. Often ()

+ Do you avoid floating fears and anxieties?
 1. Never
 2. Occasionally
 3. Often ()

+ Do you feel free of unjustified guilt feelings?
 1. Never
 2. Occasionally
 3. Often ()

+ Are your moods free of violent cycles?
 1. Never
 2. Occasionally
 3. Often ()

THAT CERTAIN SOMETHING
The Magic of Charm
by **Arlene Francis**

CHARMOMETER

Pretty clothes *do* bring happiness

Beauty IS A GIFT OF NATURE BUT ANY WOMAN CAN BE BEAUTIFULLY *DRESSED!*

Do you want to know the secret of being well dressed? It is really very simple. *"Always wear what becomes you."*

As Winifred Hudnut Valentino, the wife of RUDOLPH VALENTINO, so delightfully phrases it—

"Fashion is not a matter of making oneself belong to the styles, but of making the styles belong to oneself.

"Decide the colors, the type and design of dress that best bring out your own personality. Wear that type—make it your own.

"You will hear your friends saying—not, 'How well that dress looks on you,' but, 'How well *you* look in that dress!'"

Quite true! Such compliments do bring the sunshine into one's life. But how can a girl or woman be well dressed when her allowance is small and does not permit of the purchase of the pretty dresses that one would like to have? Ah, there *is* a problem! But it need not worry you long.

For have you not heard of the NEW Course in Dressmaking and Designing that has just been announced by the Woman's Institute as the result of its experience in teaching 170,000 women and girls?

It is so wonderfully easy and fascinating! And so surprisingly simple! Why, you begin with the *very first* lesson to make something pretty to wear. And then, almost before you know it, you are making dresses, blouses, lingerie, separate skirts; even evening wraps and gowns and coats and suits in the very latest style.

And at such small cost! Truly, even the prettiest dress costs but a trifle when you pay only for materials.

"WEAR WHAT BECOMES YOU!" Is this not easy when you make your own clothes? Is it not a joy to spend a few hours at the sewing-table when the reward is a dress or gown that brings out your individuality—that is not like three or four or a score of others, but is your very own—that is distinctively becoming to your particular type?

Do not say that you could never, never learn to make your own clothes at home. Seven years ago that might have been true. But not now!

For the Woman's Institute has already taught thousands of women and girls to make their own clothes. Surely, if all these other women and girls can learn, you can learn, too.

After all, there is no mystery about Dressmaking and Designing. It is all so easy when you know how. If you cannot sew very well now, it is not because you do not have the knack or cannot acquire it—indeed it isn't —but simply because no one has ever shown you how.

There's a certain way to make every stitch—every seam—every detail; a certain way to alter patterns—to cut the material; a certain way to do everything that the best dressmaker can do.

The Woman's Institute will teach you that way—easily—*quickly*—in spare time—right in your own home.

It will do this by an absolutely new way—by a simple step-by-step method that makes everything plain and understandable—a method that is so surprisingly easy that you will want to spend every spare moment planning and making pretty clothes.

The whole secret is that you learn by doing! You make an apron *by making an apron.* You make a dress *by making a dress.* And so on all through your course.

There is no doubt that through this New Course and Service you can now have the pretty, becoming clothes you have been wanting, at a fraction of their former cost —*and earn money besides!* Many students of the Institute not only make all their own clothes, but earn a substantial income by planning and making clothes for others.

Best of all, this Service is now yours at a cost so small it will surprise you, and on a plan convenient for you, no matter what your circumstances.

Just send the convenient coupon or a letter or postal to the Woman's Institute, Dept. 90-S, Scranton, Penna., and you will receive the full story by return mail.

WOMAN'S INSTITUTE
Dept. 90-S, Scranton, Penna.

SE DETAILS

Any one of the 13 details on the following list can spoil a perfect rating for appearance:

1 A slip that hangs at the hemline.
2 Straps that show at a low- or wide-cut neckline, or on sleeveless dresses. Use strap holders or wear a strapless bra.
3 Loose threads.
4 A hem that's uneven.
5 A bulging handbag.
6 A neckline spattered with puffs of face powder.
7 Dust or lint on coat or suit collar or shoulders.
8 Size tag showing at back of neckline.
9 A case of gap-osis at the seams.
10 Crooked stocking seams. Seamless stockings are a girl's best friend.
11 Shoes that are down at the heel.
12 Shine-less shoes.
13 White gloves that aren't spotlessly white.

AN AVON BOOK 50c G-1133

the smart girl's guide to fashion

YOU'RE BETTER OFF NAKED

What to use for money
When to believe Dior
How anyone can look Marvelous
The untold Secrets of the fashion world

WAYNE HEALY

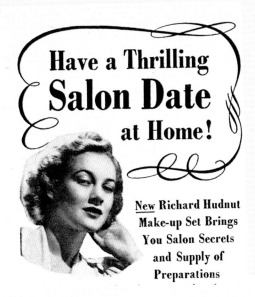

Have a Thrilling Salon Date at Home!

<u>New</u> Richard Hudnut Make-up Set Brings You Salon Secrets and Supply of Preparations

WITH YOUR STYLIST:
AVEC VOTRE COIFFEUR:

I don't want a haircut!
Je ne veux pas avoir les cheveux coupes!

I would like to have a trim...only the ends.
J'aimerais avoir un effilage...Seulement les pointes.

I don't like short hair.
Je n'aime pas les cheveux courts.

...(And for the daring ones):
I like my hair short!...J'aime les cheveux courts!

My hair is naturally wavy. Please, use big rollers.
Mes cheveux ont des crans naturels...Employez des gros rouleaux, s'il vous plait.

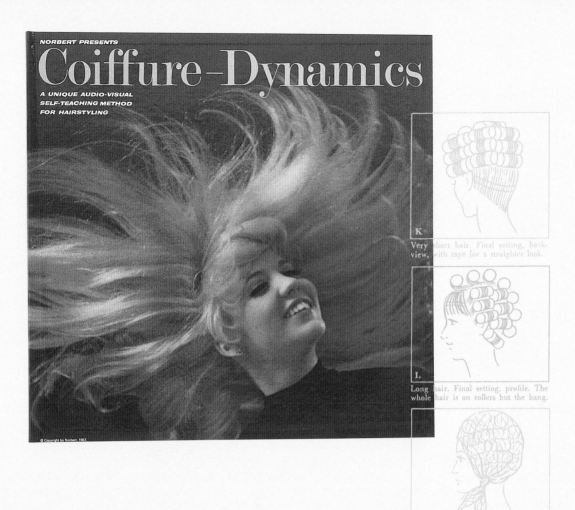

NORBERT PRESENTS

Coiffure-Dynamics

**A UNIQUE AUDIO-VISUAL
SELF-TEACHING METHOD
FOR HAIRSTYLING**

K
Very short hair. Final setting, back-
view, with tape for a straighter look.

L.
Long hair. Final setting, profile. The
whole hair is on rollers but the bang.

M
Your hair is well in place. Do secure
your set with a good hairnet.
Norbert's way: The hairnet is twisted
on the side and secured with pins.
This way, it looks more elegant and
does not disturb the neck line.
. . . Now, your hair must dry, I will
leave you for a while. During this
intermission, whether you are under
the dryer or not, read your booklet
very carefully.

LESSON TWO:
BRUSH YOUR HAIR
TO BEAUTY!
*The first step to a beautiful comb-out
is to brush your hair and brush it
THOROUGHLY.*

Are you surprised?

*Afraid perhaps, you will ruin your
set?*

*Do not worry! On the contrary, you
will be helping your hair.*

EXERCISES WHILE BRUSHING THE HAIR

(1) Lie across the bed, head hanging over the side. As you
make each stroke with the brush, kick the legs alternately back-
ward, bending at the knee. Try to make the feet hit the but-
tocks. (This position is excellent for brushing, even without the
kicking exercises, because the blood has a chance to rush to the
scalp.)

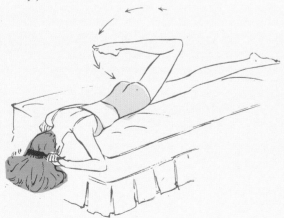

N

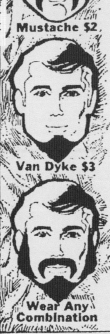
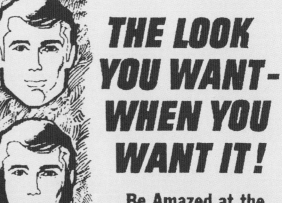

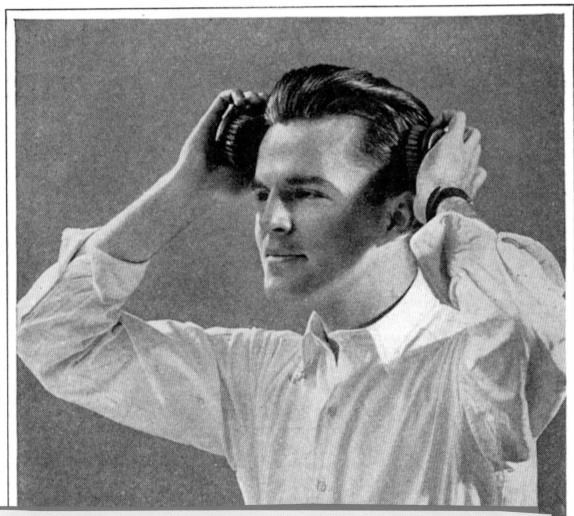

The use of the brush is an important feature in the proper care of the hair. For men a daily and even two or three times daily vigorous brushing will preserve the health and impart luster and life to the hair.

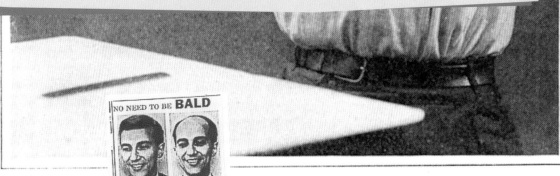

Most men clutter up their livin
in shawl-collared flannel robe

Lounging Wear

HOW SLACKS SHOULD FIT TO PLEASE WOMEN

Slacks can fit a man in several different ways. The style that elicits the most favorable responses from women is the hip hugger, particularly if it is tight and worn by a man who has the figure to support it. Another type of pants that is attractive to women are those with high waistbands, which also tend to show off a man's hips and figure. Although women like a man's pants to be tight in the hips and on the upper legs, they are also attracted to pants that flare at the bottoms, probably because the flare increases the illusion of thin hips.

WHEN TO BARE YOUR CHEST

Most women like men in open shirts, but they expect this display of masculine chest to be confined to appropriate locations: at a bar, on the beach, at a sporting event, at his apartment or hers, but not on Fifth Avenue in New York. There, women find it tasteless and not very sexy.

A "Body" Shirt
with Tapered Accent Lines,
Which Make the Chest
Look Larger and
the Waist Look Slimmer

ms

No. **5**

In order to get married, one must first get a date. To get a date, one must of course look good and feel great, be well groomed and socialized, etc. Love and marriage are the shining goals, the ideal bliss whose achievement drives all other self-help impulse. The stakes are high, and we need all the help we can get. Helen Gurley Brown's revolutionary SEX AND THE SINGLE GIRL illuminates the pleasures of single life, as does its answer-of-sorts successor, Dr. Albert Ellis's SEX AND THE SINGLE MAN (including "To Masturbate or Not," "Adultery Anyone?," and "How to Avoid Becoming a Sex Pervert"). WIN YOUR MAN AND KEEP HIM cuts right to the chase with real how-to hints for the matrimonially inclined. That accomplished, is hubby happy? SEX SATISFACTION AND HAPPY MARRIAGE and the album "MUSIC TO KEEP YOUR HUSBAND HAPPY" offer need-to-know information on keeping the knot tied. With another perspective, Mrs. Norman Vincent Peale describes her own secrets for happiness in THE ADVENTURE OF BEING A WIFE (positive thinking?). Husbands, although no less in need of guidance, find fewer resources dedicated to their improvement, but do learn in SEX, LOVE & MARRIAGE that marks of being a good spouse include having "respect for your wife's brains and opinions" and not referring to mother too often. Finally, tips for teens in love, applicable now as ever, prove that the best advice on matters of the heart is truly timeless.

LOVE AND MARRIAGE

> **Theoretically, a 'nice' single woman has no sex life.**

"What nonsense!"

says Helen Brown, author of this entertaining and refreshingly frank study.

Her book is the first that dares to recognize the physical as well as the emotional needs of the single woman. Based on her own experiences and those of her friends, it includes:

✓ A five-minute lesson on the art of flirting

✓ A chapter on "The Affair: From Beginning to End"

✓ 17 different ways to meet men

✓ The pros and cons of getting involved with married men

✓ An eye-opening discussion of virginity

✓ And personal advice-packed sections on MEN— how to catch, keep and (if you're inclined) get married to one of them.

PRINTED IN U.S.

PUBLISHED BY POCKET BOOKS, INC. pb

pb

₱

75c

GIANT CARDINAL EDITION GC-783

THE COMPLETE BOOK

The unmarried woman's guide to men

SEX AND THE S1NGLE GIRL

Helen Gurley Brown

The sensational best seller that torpedoes the myth that a girl must be married to enjoy a satisfying life

A Sexy Kitchen

Have an extravagant spice shelf with possibly thirty spices. They say you're a good cook. A man who is possibly a bit of a cooking buff himself will be enchanted with them....Ice-crushers, lemon-peel peelers, heavy stainless steel bottle openers, corks with a carved head on them—anything gadgety usually pleasures a male.

Travel Posters

Coax these from United, American, TWA, Pan-American or any of the foreign airlines which have exciting travel posters. They are a trifle masculine but look great in hallways or kitchens. I have a TWA matador over my kitchen stove that's really goose-bumpy.

Television

Have a TV set for quiet little evenings at home and shows of major importance but not too *great* a TV set or you'll never get out of your apartment.

IF MARRY YOU MUST:
How to Pick a Suitable Wife

Never marry until you have known at least a score of women intimately. Then you may not want to! More seriously: never marry until you first know yourself—know what you tend to like and dislike about women. And the only safe way to know yourself in this connection is to know a good many women intimately and to spend as much time with them as possible.

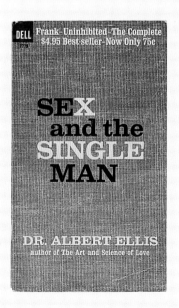

DELL
Frank—Uninhibited—The Complete
$4.95 Best-seller—Now Only 75¢

SEX and the SINGLE MAN

DR. ALBERT ELLIS
author of The Art and Science of Love

No marriage is doomed to failure by a wife's working out. But any marriage may be. It's the risks that a working wife takes that we ask you to consider. There's a risk, for example, that her job may become so interesting to her as to alienate her affections. Or maybe the boss, or the office Don Juan, will do that for her more directly. Or maybe her pay will be enough to put her in direct competition with her husband, perhaps enough to put her in a superior position—and what that can do to a husband's ego surely needs no underlining. Her greatest risks lie in her relations with her husband and her children, the care and feeding of whom simply can't be handled adequately on a part-time basis....To depart from this essential role is to gamble with happiness. Such gambling is at best a necessary evil. And the less necessary it is, the more evil.

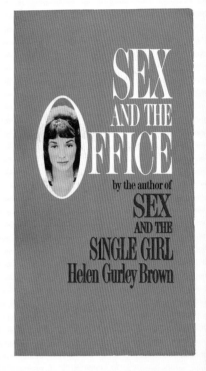

TO IMAGE OR NO

A lot of women in business have images. A girl who later started a magazine and became a hostess to royalty used to trail mink on the floor behind her when she was a mere slip of a secretary. She also used to move her two good Louis XV chairs down to the office to impress a lunch date, then have them hauled right back home to wow the cocktail trade. Her image was Opulence. (Don't ask me how she did it on her salary! I've heard some conjecture, of course.)

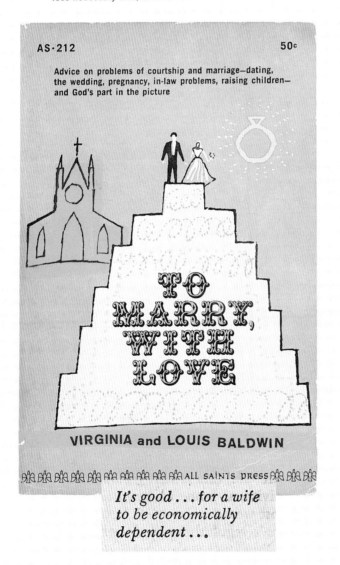

AS·212 50c

Advice on problems of courtship and marriage—dating, the wedding, pregnancy, in-law problems, raising children—and God's part in the picture

TO MARRY, WITH LOVE

VIRGINIA and LOUIS BALDWIN

ALL SAINTS PRESS

It's good ... for a wife to be economically dependent ...

Read it, and you'll find out:

- ✓ How to love a boss. ("Imperative for any girl who wants a rich, full office life.")
- ✓ How to be a fulfilled secretary.
- ✓ How to move onward and upward "where the money, the men and the spoils are even greater."
- ✓ How to de-fang your office enemies.
- ✓ How to dress up to here and down to there to enchant every male co-worker.
- ✓ Combat instructions for Jungle Warfare (office politics).

O IMAGE?

You'll also:

- ✓ Learn how business travel can be the sexiest of all office adventures.
- ✓ Visit Lunchland for rollicking coeducational feasts ... have fun for a change at the office party.
- ✓ Read Three Little Bedtime Stories—and a Very Special Report on The Matinee.

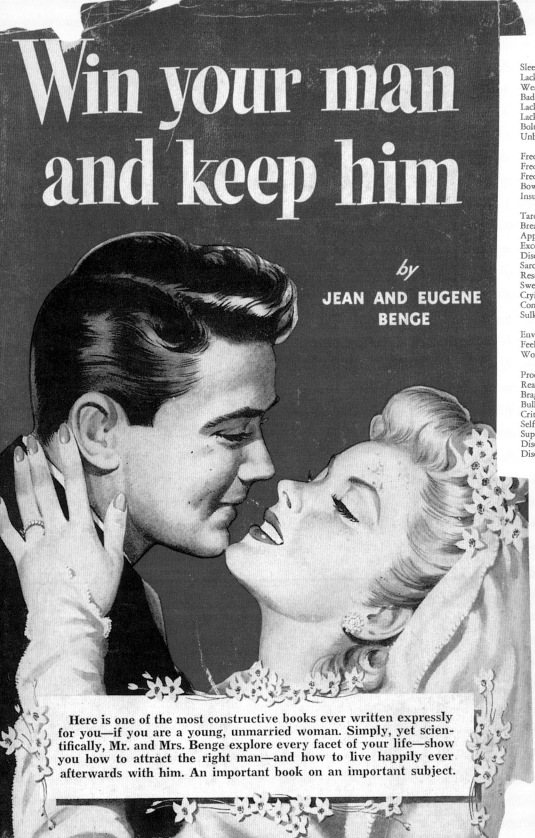

Win your man and keep him

by

JEAN AND EUGENE BENGE

Bad Living Habits

Sleeping after the alarm clock rings
Lack of adequate bathing
Wearing dirty or sweaty clothing
Bad posture
Lack of sun, fresh air
Lack of exercise
Bolting food
Unbalanced diet

Frequent use of sedatives
Frequent use of anti-acids
Frequent use of laxatives
Bowel irregularity
Insufficient drinking water

Tardiness
Breathless haste
Applying make-up publicly
Excessive tobacco or alcohol
Discourteousness; impatience
Sarcasm; irony
Resentment; anger; hysterics
Swearing
Crying; whining
Contradicting; interrupting
Sulking; moodiness

Envy; jealousy
Feeling sorry for yourself
Worrying; fear

Procrastination; indecision
Ready discouragement
Bragging; over-talkativeness
Bullying
Criticising
Self-excusing; blaming others
Super-independence
Disobedience to rules and customs
Disorderliness with possessions

Here is one of the most constructive books ever written expressly for you—if you are a young, unmarried woman. Simply, yet scientifically, Mr. and Mrs. Benge explore every facet of your life—show you how to attract the right man—and how to live happily ever afterwards with him. An important book on an important subject.

Good Living Habits

Prompt and regular rising
Frequent bathing
Clean clothes, changed as needed
Erect but not tense posture
More outdoor activity
Indoor or outdoor exercise
Leisurely eating
Mixed diet; green vegetables and
 fruits
Calm life
More sensible foods
More fruits, vegetables, roughage
Build up regularity
Drink 6 to 8 glasses of water per
 day
Planning for promptness
Leisurely pace
Careful make-up in private
Reduce or avoid tobacco or alcohol
Courtesy; patience
Sympathy; helpfulness
Acceptance; restraint; self-control
Whistling, humming
Enduring; preventive action
Considering; listening
Assume an air of friendliness; dis-
 tractions
Work harder; be more friendly
Count your blessings
Keep striving; face your ob-
 stacles
Do it now; force yourself to decide
Keep everlastingly at it
Modesty; restraint in conversation
Gentleness
Constructive suggestions
Accept responsibility; admit errors
Cooperation
Conformity
A place for everything; everything
 in its place

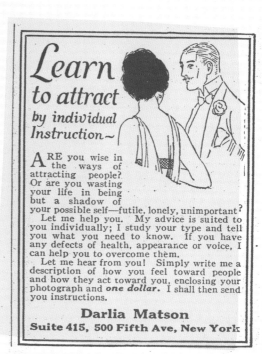
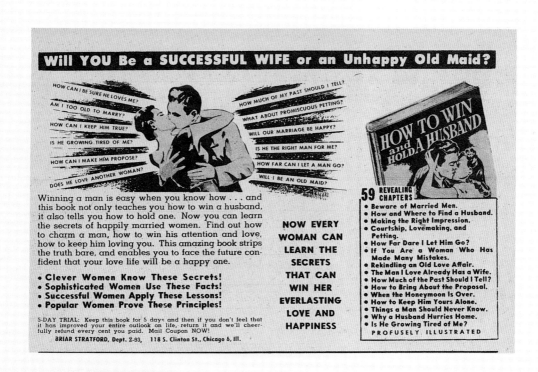

DIFFERENT POSITIONS FOR COITUS

THERE are different positions that can be taken in sexual intercourse and it is desirable that the position should be varied just as often as fancy may chance to dictate. Variety in sex technique, as in most other things in life (tea out in the garden, for instance), adds a certain spice that need not be refused for any reason known to common sense.

SEX SATISFACTION and HAPPY MARRIAGE BY THE REVEREND ALFRED HENRY TYRER

The Simplest and Best of the Many Books on the Subject—Mail and Empire

Foreword by ROBERT L. DICKINSON, M.D.

Angela Human

THE KIND OF WOMAN A MAN WANTS

Angelic Qualities

Human Qualities

1. Understands Men

1. Femininity

2. Has Deep Inner happiness

2. Radiates Happiness

3. Has a worthy character

3. Fresh Appearance and manner

4. Is a Domestic Goddess

4. Child-like-ness

The Angelic side of woman arouses in man a feeling approaching worship. These qualities bring peace and happiness to man.

The Human side of woman fascinates, amuses, captivates and enchants man. It arouses a desire to protect and shelter.

TOGETHER HE CHERISHES
BOTH ARE ESSENTIAL TO HIS CELESTIAL LOVE

The Angelic is what a woman *is*, and has to do with her character.

The Human is what a woman *does* and has to do with her appearance, manner, and actions.

LOVE AND MARRIAGE

You are a good husband: ★ *If you tell your wife often that you love her.* ★ *If you are a good provider.* ★ *If you are neat about your person and clothes.* ★ *If you have a cheerful disposition.* ★ *If you are thoughtful and considerate.* ★ *If you are helpful with the children.* ★ *If you are loyal.* ★ *If you respect your wife's brains and opinions.* ★ *If you practice a reasonable amount of self-control.* ★ *If you don't refer to mother too often.*

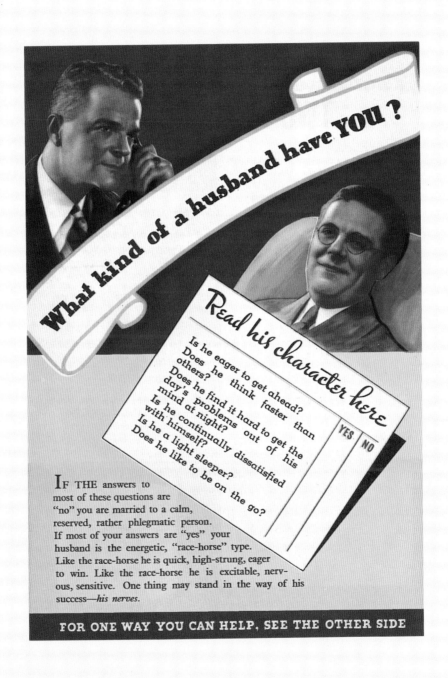

What kind of a husband have YOU?

Read his character here

Is he eager to get ahead?
Does he think faster than others?
Does he find it hard to get the day's problems out of his mind at night?
Is he continually dissatisfied with himself?
Is he a light sleeper?
Does he like to be on the go?

YES | NO

IF THE answers to most of these questions are "no" you are married to a calm, reserved, rather phlegmatic person. If most of your answers are "yes" your husband is the energetic, "race-horse" type. Like the race-horse he is quick, high-strung, eager to win. Like the race-horse he is excitable, nervous, sensitive. One thing may stand in the way of his success—*his nerves.*

FOR ONE WAY YOU CAN HELP, SEE THE OTHER SIDE

STUDY YOUR MAN

If I could give one piece of advice to young brides, and only one, it would be this: *study your man*. Study him as if he were some rare and strange and fascinating animal, which he is. Study his likes and dislikes, his strengths and weaknesses, his moods and mannerisms. Just loving a man is fine, but it's not enough. To live with one successfully you have to know him, and to know him you have to study him.

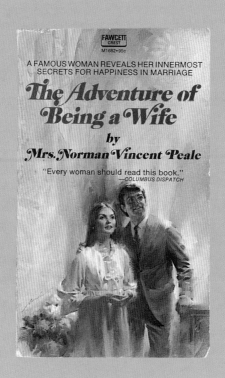

A Practical Guide to Happy Marriage

The MARRIED WOMAN

The latest findings of science are combined with wide experience in this celebrated handbook. It shows you how to avoid the needless worries of marriage, how to meet its problems, and how to taste its pleasures fully.

Gladys H. Groves & Dr. Robert A. Ross

BETH WHEELER
(MRS. ELMER WHEELER)

How to help Your Husband Relax

A wife prescribes happiness instead of tension as the key to success

WOULD YOU RATHER YOUR HUSBAND HAVE TWO WITH YOU OR SEVERAL WITH THE BOYS?

Here is an excellent relaxative for a tired husband when he comes home from a busy day at the office: sit down and have a glass of beer or a martini with him, perhaps two. Isn't that infinitely better than having him knock off several with the boys on the way home? Because if he comes home late and a little tipsy, you are apt to become irritable because he kept dinner waiting, and a beautiful dinnertime argument ensues, at the time when a man should be most relaxed.

Do not grind your teeth in your sleep, thrash around with your clenched fists, or toss and twist so much that you wind the bedclothes into a tight cocoon around yourself, leaving your pillow-partner bare. Try to turn off the radio at an early moment after midnight. All these things require some self-denial, but remember what Emerson said: "Good manners are made up of petty sacrifices."

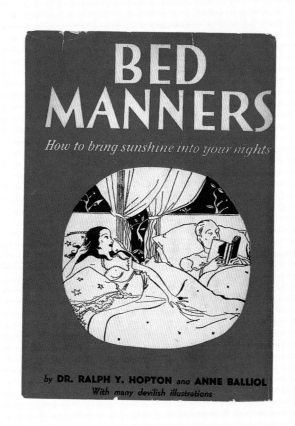

BE PRETTY AT BREAKFAST

We have no statistics on how many husbands rush off to a day's work without breakfast. But we'll bet a dollar to a doughnut we know who's to blame. His little helpmate—that glamour girl who became a scarecrow after he married her.

You can't blame the poor man for losing his appetite if he has to face a drab, sleepy-eyed, hair-in-curlers woman over the breakfast table. No secretary ever looks like that to him.

Of course you don't have to go to extremes in the other direction, like the bride who never removed her make-up until the lights were out, and got up an hour before her husband awoke to have time for a complete make-up.

You can have your beauty treatment, without freightening your spouse out of the house. The trick's to do it when he's not around.

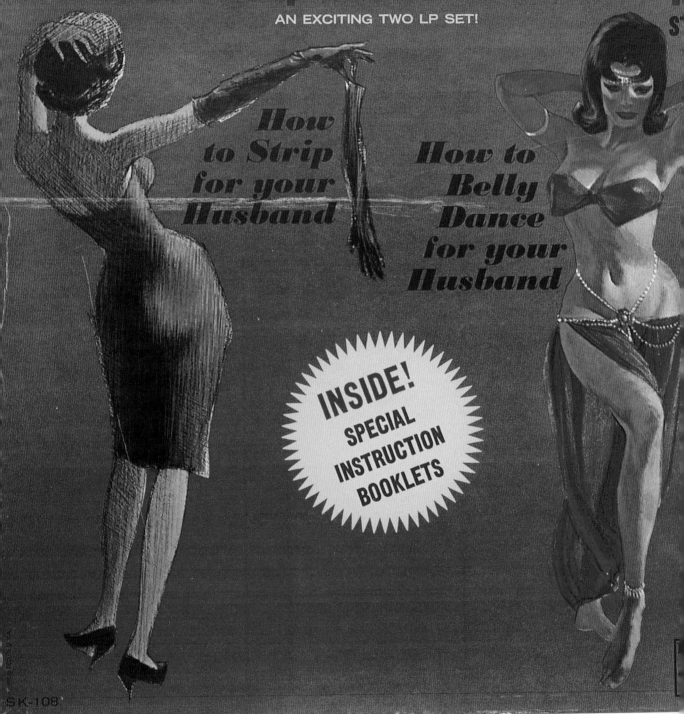

CHECKLIST FOR KEEPING YOUR HUSBAND HAPPY

- ✦ Firm and graceful body.

- ✦ Be at home when he arrives. (If you must work, try to arrange it so you're home first.)

- ✦ Clothes, sexy—for your evenings home.

- ✦ Be interested in him and the things he does.

- ✦ A good conversationalist.

- ✦ A bright smile over morning coffee. (This paints a good mental picture of you for all day.)

- ✦ Nice voice (keep it soft and musical; also a pretty laugh).

- ✦ Excess fat (taboo).

- ✦ Well-set hair (brushed and clean).

- ✦ Mentally alert (try reading).

- ✦ Pin-curls (if they are a must, pin up after the lights are out and wear a bed cap).

- ✦ Perfume—just for him, when he's home.

- ✦ A regular manicure.

- ✦ A weekly pedicure.

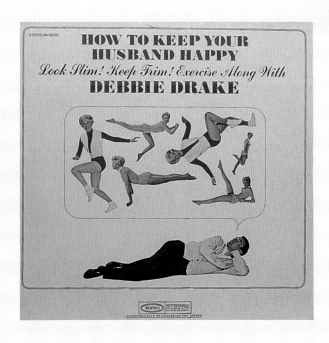

The inexperienced girl may wonder, "If he tries something, shall I slap him and run, or just run?" The more mature girl knows that she doesn't need to resort to either slapping or running in order to deal with the too amorous boy friend. She wards off unwelcome behavior with a firm refusal to co-operate, accompanied by a knowing smile and a suggestion of some alternative activity. She may say, "Not now, Ambrose—let's go get a hamburger; I'm hungry."

When a Fellow Gets Fresh

WAYS TO FORGET HIM ✿ Take his picture out of the frame and either burn it or bury it deep down under things you rarely use. Seeing it will only open the old wound again ✿ Destroy the letters he wrote you. If you cannot get yourself to tear them up, then at least put them away where you will not be tempted to reread them ✿ Dispose of the gifts that he gave you. Return the things that are valuable to him. Give the others away, or at least lock them up where you won't see them for a long time ✿ Start a new diary. The old one is so full of him that every time you write a new entry you will be reminded of something you did together. It is just not worth it.

Teen-Ager Should Know

OF
ND LOVE
AGERS

National Board of Y.M.C.A.'s,
edition of this book

When
children
start dating

Better
Living
Booklet

For
Parents
and
Teachers

EDITH G. NEISSER

*Boys and girls need our help
and understanding when they're learning
to get along with the other sex.*

**Young teen-agers love picnics, car-
nivals, skating and splash parties.**